Symptomatic: Recent Works by Perry Hoberman

SYMPTOMATIC

Recent Works by Perry Hoberman

Symptomatic: Recent Works by Perry Hoberman

National Museum of Photography, Film & Television, Bradford

21 September – 1 December 2001

Published by the National Museum of Photography, Film & Television, Bradford, England
(part of the National Museum of Science & Industry)
© 2001 National Museum of Photography, Film & Television, Bradford, West Yorkshire BD1 1NQ

National Museum of Photography, Film & Television
Bradford, West Yorkshire BD1 1NQ
Telephone: +44 (0) 1274 202030
Facsimile: +44 (0) 1274 723155
World Wide Web: www.nmpft.org.uk

Designed by Herman Lelie
Typesetting by Stefania Bonelli

Photography:
Cover image by Ian Tilton
Timetable and Workaholic by Ian Tilton
Lightpools by Guillem Cascante and Perry Hoberman
Cathartic User Interface by Perry Hoberman (image p.16 courtesy of Postmasters Gallery, New York)
Bar Code Hotel by Perry Hoberman

Printed in Great Britain by Clifford Press

ISBN 0948489219

Contents

Foreword

In *Symptomatic: Recent Works by Perry Hoberman*, a unique body of work makes its first appearance in the UK. The exhibition is the centrepiece of the current Bradford Fellowship project, a partnership between Bradford University, Bradford College and the National Museum of Photography, Film & Television. Established in 1984, the Bradford Fellowship is awarded every two years to an artist of international standing.

Symptomatic: Recent Works by Perry Hoberman presents three installations that invoke radically unfamiliar technological realities. The result is an explosive mixture of experiment, critique and play, through which the willfully subverted dynamics of the gallery spill out into the world at large. Hoberman's materials range from the everyday to the exotic, and from the ancient to the state of the art. Combined, they make for vertiginous juxtapositions that recall an aesthetic theme long associated with the Surrealists through the Comte de Lautreamont's 'chance encounter of a sewing machine and an umbrella upon a dissecting table'. But the significance of Hoberman's unexpected juxtapositions lies squarely in our contemporary social/technological world, not in the mysteries of the subconscious. His hi-tech readymades reanimate the Dadaist grammar of absurdity, incoherence and chance, holding up a mirror to some of the bizarre technological collisions of everyday life. This movement passes from objects into imagery, in graphic/thematic cycles that transport us in an instant from one world to another – hence Hoberman's invocation, in *Timetable* (1999), of 'time travel, multiple branching universes, alternate dimensions and shared hallucinations'. Spatially, all three pieces revolve around circular 'arenas', reminiscent of dancefloors and fairground games. Sound effects, soundtracks and a host of mingled noises dissolve the boundaries between them, creating an atmosphere closer to the arcade than the museum.

From disparate ingredients – alien recombinations of objects and spaces, images and sounds – Hoberman assembles strangely coherent new wholes. Each work is a kind of system, subsuming its parts to create a partial and temporary unity governed by a compelling, but mysterious, internal logic. Alongside the logic, however, lies an insistent and pervasive undecidability. The systems are not closed. They come to life through the participation of the gallery visitors, who both follow and direct the flow of activity and meaning. The relationship is one of constructive antagonism: the 'rules' of the game take shape, then promptly fall – or are pushed – apart.

Hoberman's works intervene in the processes of unnatural selection through which new media interfaces emerge. They are benignly subversive social experiments, refusing the cell-like individuation of computer workstation and video game. If we enter the game, sooner or later we find ourselves cornered, and forced to engage – or to refuse to engage – with the other participants. This exposes another of Hoberman's favourite targets: the social dynamics of the gallery itself.

Hoberman makes refreshingly direct assaults on those aspects of daily life that we most readily take for granted. *Workaholic* is about work: ceaseless, pathological work, without clear goals, with only partial (or illusory) control. *Timetable* is about time: social time, machine time; time skewed, distorted, produced and consumed. But again, the level of direct speech – about work, or time, or whatever – gives way to one of radical disorder. Like a virus, each work enters and destabilises the technological ecology, undermining the basic terms of familiar objects and experiences. By distorting their being and their context, Hoberman derails a wider set of relationships. The instability is already there, at the heart of discourse and of technological systems. Working from within, Hoberman's interventions intensify this disruptive play. Undoing presumptions and stirring up underlying levels, he is both *agent provocateur* and gleeful prankster.

Perry Hoberman has been a pioneering force in media art for two decades. He is the tenth Bradford Fellow, and the first non-photographer to receive the award. Previous Fellows have included Paul Graham, Raghubir Singh, Fay Godwin, David Hurn, Nancy Honey, Eamonn McCabe, George Tice, Nick Danziger and Evergon. The Museum would like to extend its heartfelt thanks to Perry Hoberman, the Fellowship Committee and everyone who has contributed to the exhibition, the catalogue, or any of the other activities of the current Fellowship project. The artist would like to extend a special thanks to Janis Britland.

Patrick Henry
Curator of Exhibitions
National Museum of Photography, Film & Television, Bradford
10 September 2001

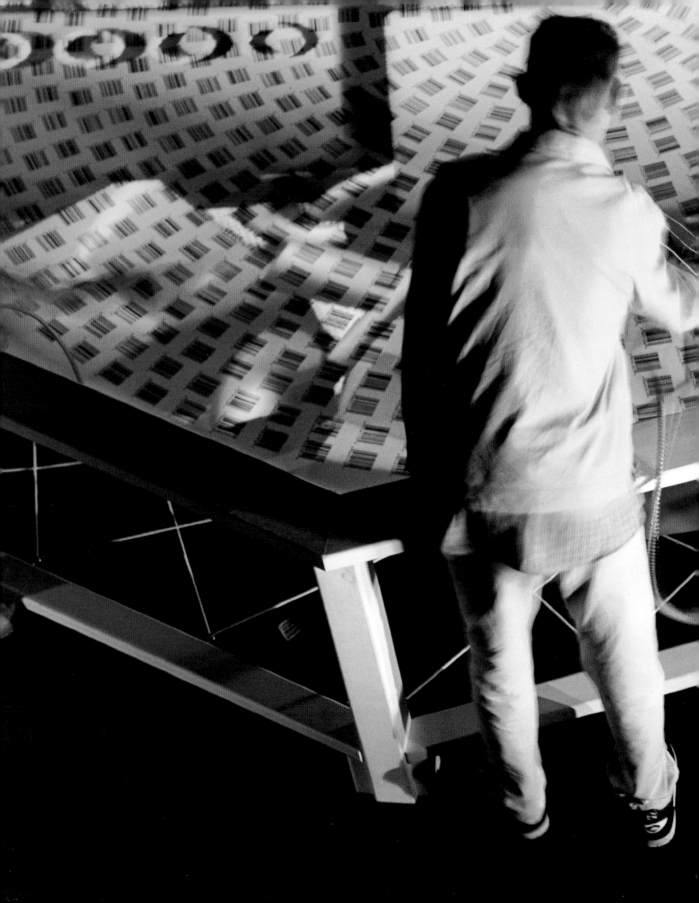

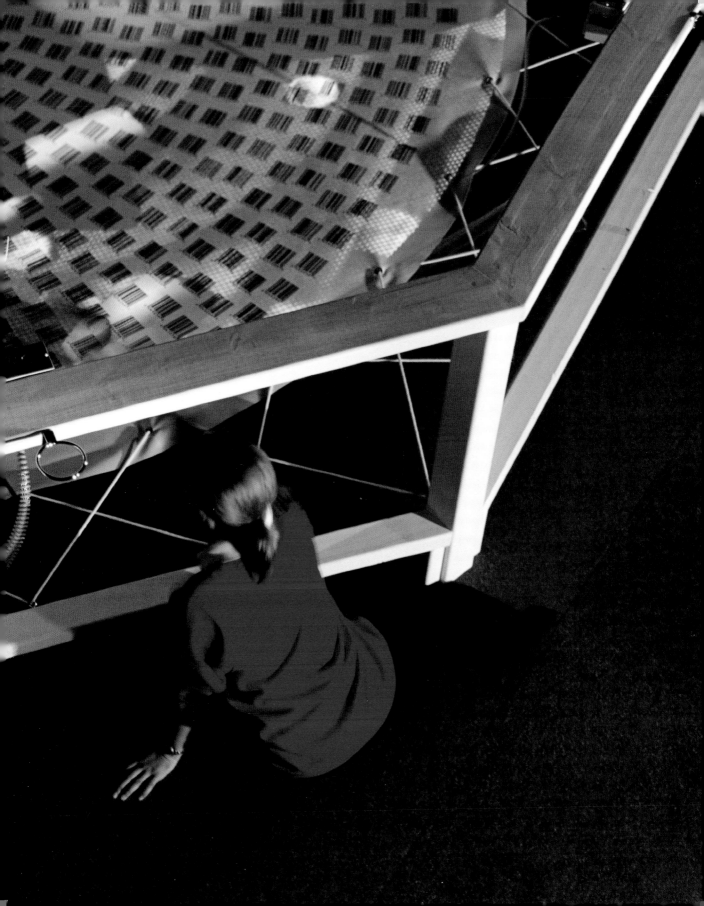

For an Expanded Epic Art through Media – Against Psychopathia Medialis: Miniature on the Work of Perry Hoberman

Siegfried Zielinski

Art created with or through media is usually regarded as being without pre-conditions. The shining aura of the brand new is so compelling that it is tempting to sacrifice everything to it, including a knowledge of history. Yet artistic praxis that engages with present-day or just-invented media apparatuses and systems and attempts to elicit vibrations and meanings from them, other than the designated perspective of their common or garden usage, is not without pre-conditions.

This statement is not intended to underline the trivial observation that all art – if it wants readers, spectators, observers, listeners, or participants – needs objectification with the help of the media (even if its nature is extremely short-lived, as in the telematic networks). I am referring to the kind of artistic praxis that has arisen within the immediate context of the technical media and which has existed now for around 450 years since Giovan Battista della Porta designed in Naples a model of an allegory machine with flat mirrors which Athanasius Kircher then developed for construction in the middle of the seventeenth century.[1] My concern is less the long genealogy of artifacts and projects and more the fact that in the past, there have always been constellations and ways of posing problems in the interrelationship between art and apparatus that have not changed dramatically over time because they really are fundamental, that is, in a very basic way they are concerned with this strange area between machinists and machines that today we call *interface*.

In the 1970s, when Perry Hoberman was still painting (I don't know if he still does), he made two pictures that immediately grabbed my attention when I saw them.[2] They cited the title of a great film, A Nous La Liberté by René Clair, and revisualized two of its central shots. These are shots no. 499 and no. 500, described in a later protocol of the film as follows: '499. Medium long shot from behind of the GANGSTER with the case under his arm rushing towards the main staircase of the office building ...' and '500. High angle medium shot of the office; LOUIS [the main character of the film] is sitting in soft focus in the foreground, back to camera, behind his desk. He jumps up as the door opens and the gangsters crowd into the office.'[3] In 1976, Perry

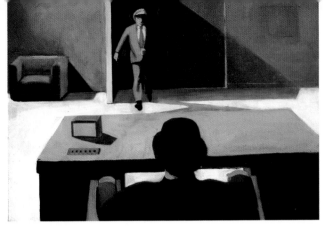

A Nous la Liberté 1976

Still from the film *A Nous la Liberté* 1931
directed by René Clair

Hoberman painted this cinematographic play of light, colour, and action – in colours and style a little reminiscent of Edward Hopper – as a frozen moment of that time. Clair's film impressed Charlie Chaplin so deeply that with *Modern Times* he created a kind of adaptation. After the film's completion in 1931, Clair wrote: '*A Nous La Liberté* is not a film for serious people. If you believe work to be the most important thing in life, do not go to see it, but send your children. There would be fewer employed today if the moralists had not established a religion of work in the past. We must work in order to live, but it is absurd to live merely in order to work. If work were intelligently organized, if machines worked for man instead of against him, this film would have no reason to exist ...'[4]

Around 70 years ago, the capitalist–industrial world was plunged into one of its deepest crises. Former harbingers of salvation and liberators from anxiety began to change into their opposite, from the workers' point of view. Increasingly, machines began to substitute for human hands, arms, and even heads. In conjunction with an economy that was mercilessly profit-oriented, for many, the constructions that had once been hailed as iron angels, like God's messengers on earth, became monsters and works of the devil. In Clair's film (as in Chaplin's a few years later) not only the critique of industrial exploitation plays an important role, against which both film-makers introduce a free and anarchic economy of extravagance.[5] *A Nous La Liberté* is also a wonderful cinematographic discourse directed against standardization and monotonous work that result from normed operating systems. Before the two protagonists break out of jail,

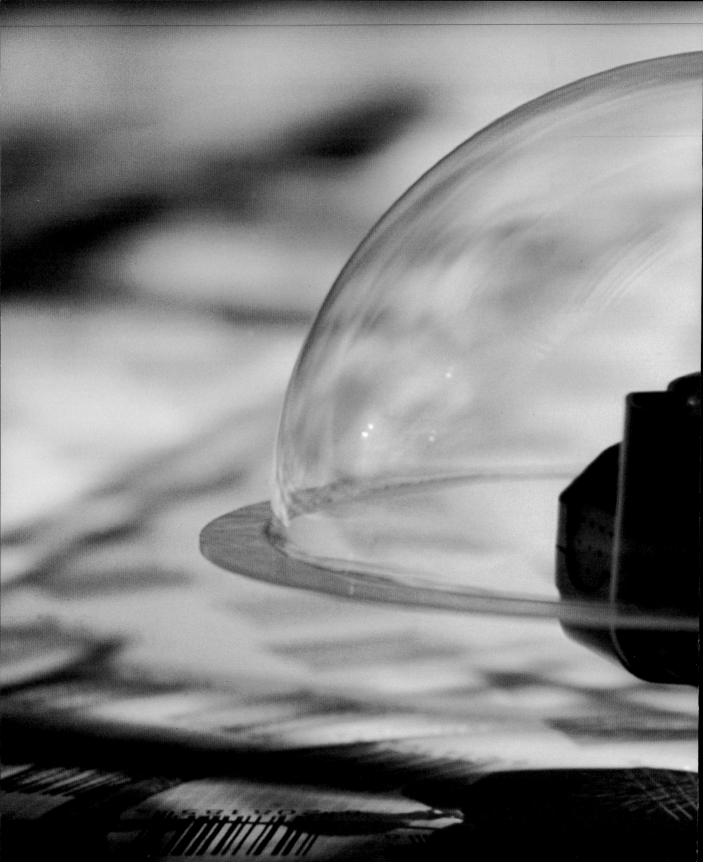

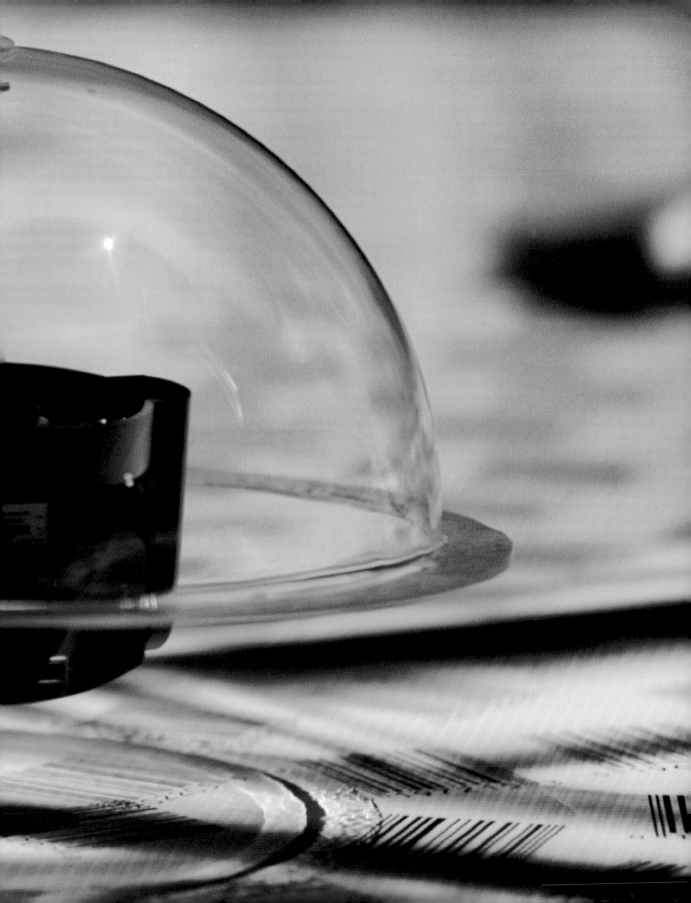

there is an impressive scene featuring their stupid work on an assembly line producing wooden horses. Afterwards, the story centers on Louis's short-lived brilliant career as manufacturer of gramophones and records. *His Master's Voice.* In this way, René Clair formulates an artistic critique of media within the medium itself, for the sparse dialogue of the film and the way it operates repeatedly with discrete shifts of image and sound were also a manifesto directed against the simple varieties of talkies and musical films that abounded after the advent of sound in motion pictures.

Perry Hoberman is one of the few engaged in the production of contemporary art with and through media who can bring off such a balancing act against the foreground of the present constellation between media people and media machines. Under conditions of increasingly immaterial labor at monitors and keyboards, the trends toward standardization and intellectual desertification are not getting any weaker. On the contrary: the universalization of information technology and the globalization of the economy are immensely powerful forces in the production of a worldwide, uniform structuring of time and cultural signification. Thinking and artistic praxis that intervene in these processes are of even more crucial importance at the beginning of the new millennium than they were at the end of the old one.

'Thinking that intervenes' was for Bertolt Brecht, who wrote his most important text on the subject at the same time as Alan Turing was writing his 'intelligent machines,'[6] an alternative to optional thinking, which permanently demands the recognition of the world of commodities as the real world. Brecht's *Short Organon for the Theatre* is a theoretical and practical appeal for operational dramaturgy and a dramatic art which are not merely an invitation to illusion and catharsis. Instead, he advocates a dramatic art that does not allow thinking to be suspended, does not view enjoyment and reason as adversaries but as two entities striving with each other in a fascinating social game that we can call art.

Present-day techniques for producing illusion, from cinematography to television and on to the networked machines and programs of the World Wide Web, are indebted to a very old aesthetic model, which is named after its inventor Aristotle. The central concepts are empathy and catharsis. The users of media apparatuses and systems are supposed to enter the experience of an artificial world as smoothly as possible, move around within it as easily as in the world outside the machines: they can get their kicks there, collect orientations and sensations which allow them to cope with the non-visible side of reality, and survive there with enjoyment. Following the jargon of the military establishment, from whose laboratories these techniques of expanded illusion all (without exception) came, today these strategies are called telepresence, simulation, immersion, interaction. We urgently need an expanded epic art and dramaturgy that do not leave us sense-less but which strengthen our senses and sensitize us, aided by media technologies, to the remainders of the non-visible: in short, a dramaturgy of the difference.

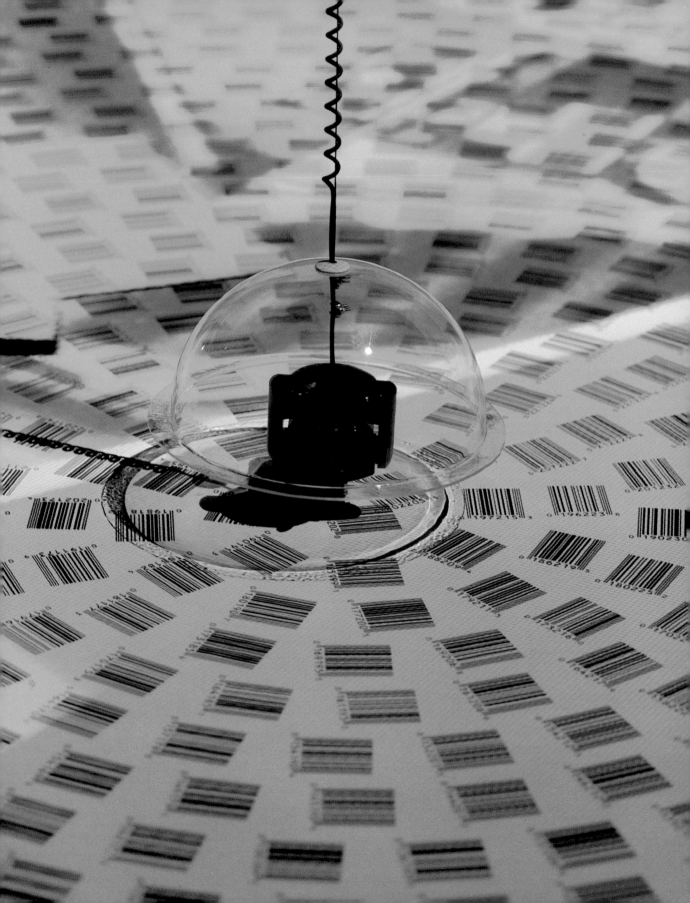

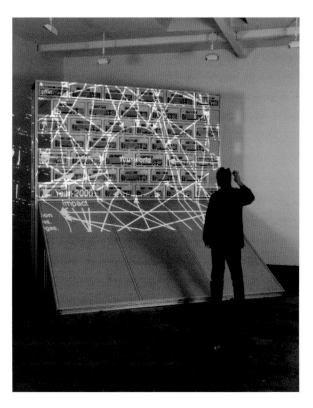

Cathartic User Interface 1995/2000

On the surface, the first version of the installation *Cathartic User Interface*, developed in 1995 by Perry Hoberman with Nick Philip, makes use of the need to vent the frustrations and aggressions that arise from dealings with the external interfaces of personal computers and their producers. As in many of his other works, here Hoberman falls back on the rudimentary experiences of everyday culture, namely, throwing soft balls at stacks of tin cans, familiar from the fairground sideshows of our childhoods (and of our children's, too), where direct hits are rewarded with small toys. However, in the installation, keyboards replace the tin cans. If one hits one of the active keys, there is no reward in the shape of an artifact from the world outside the game. The prizes are technical images projected onto the wall (and the keyboards) and they are all from the world of machines and programs: ironic user instructions or error messages, satirical shifts in the user interface, or faces of computer-industry agents. The physical exertion of throwing things at these objects of anxiety and aversion evokes a short-term liberating effect. However, the desired catharsis does not occur. The rewards proffered come only from the world of machines and programs; a short in the cybernetic system – one cannot get the better of a programmed, grammaticalized, and standardized world by machine wrecking. That course of action was already doomed to failure in the century before last. The only effective intervention in this world is to learn its laws of operation and try to undermine or overrun them. We have to give up being players at a fairground sideshow and become operators within the other world in order to work on its otherness. (Emile and Louis manage to break out of the prison in *A Nous La Liberté* by taking the tool they used to make the meaningless horses and reversing its intended function; with the aid of the file, they saw through the bars of their cell.) An important part of the concept of the *Cathartic User Interface* installation is that several users can be active at the same time. This is found in many works by Hoberman. The presence of several people together in a lighted room invariably leads to interaction between the visitors, which is, for example, not possible in the darkened cube of the cinema where feelings (occasionally) celebrate their orgies (Roland Barthes). This is *expanded cinema* of a special kind.

Jean Luc Godard has made films that have helped generations of cinema-goers and film-makers not to give up the hope that media work that intervenes does make sense, can be pleasurable, and has a future. On this subject, the extremely erudite critic and director has formulated statements time and again that have severely upset theorists and cinephiles alike, who subsequently retreated to write reams in response. When Godard proclaimed at the end of the 1960s that it was now less important to make political films than to make films politically, he initiated a discussion that is known today in the young history of media theory as the Apparatus Debate. The first theoretical foundations were laid by dentist and novelist Jean-Louis Baudry, followed by his colleague, the critic and film-maker Jean-Louis Comolli. In the course of this debate, Christian Metz rewrote his rigorous structuralist analysis of film in the concept of the Imaginary Signifier.

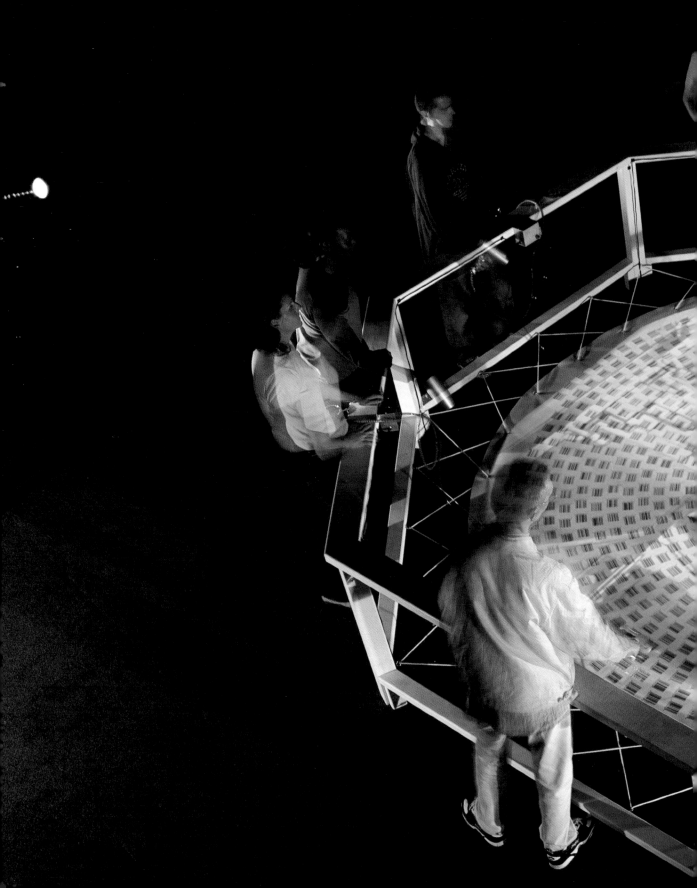

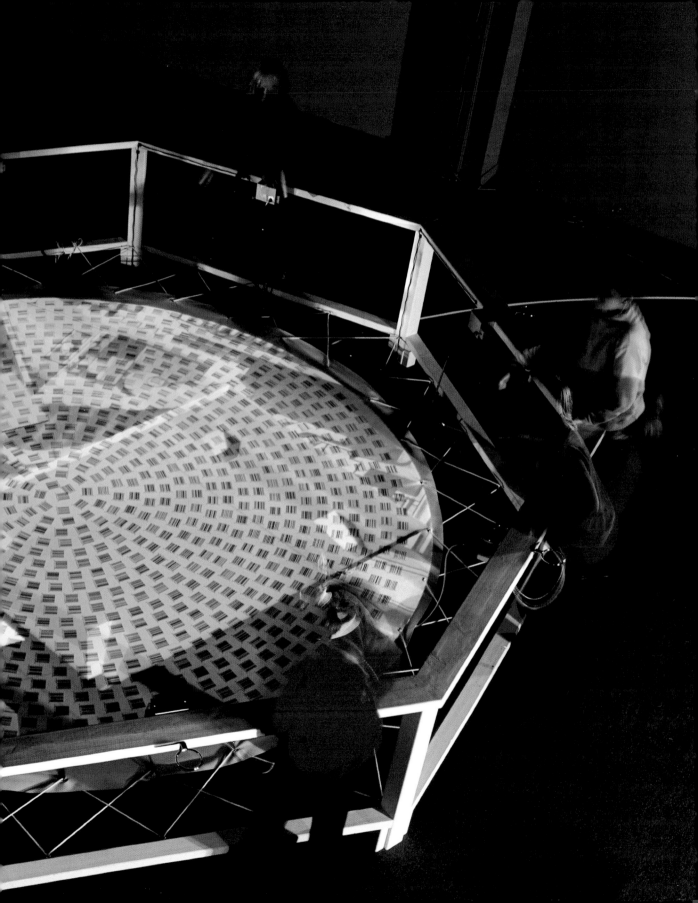

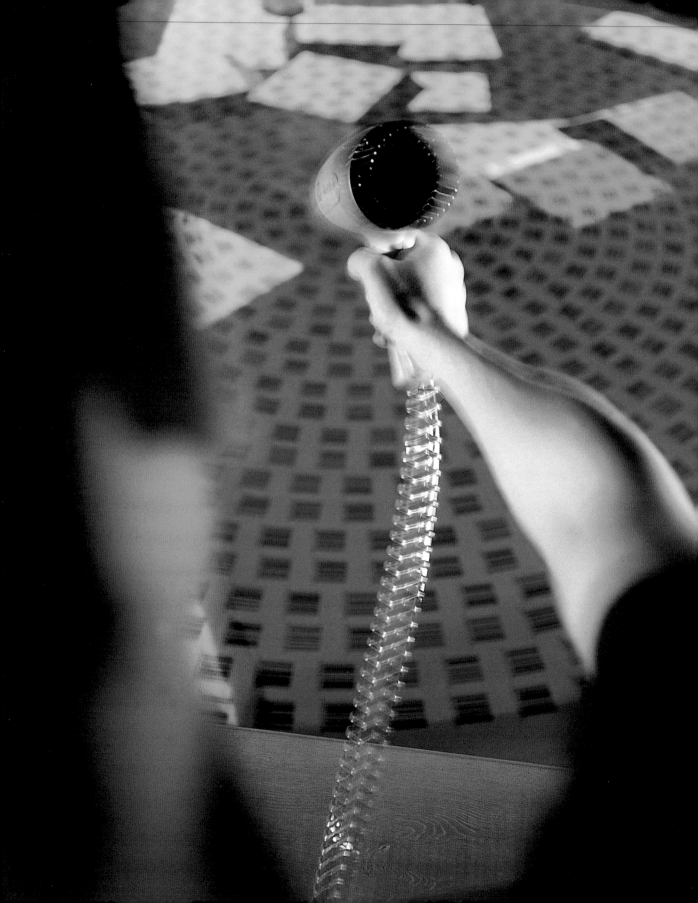

It was a many-faceted debate. For the first time since René Fülöp-Miller's brilliant book *Fantasy Machine* of the early 1930s, influential ideas from psychoanalysis (Freud and Lacan) flowed into the debate on cinema. Baudry combined these ideas with the neo-Marxist position of Althusser and even included the German philosopher Husserl's Phenomenology. However, the central item of the debate, which was principally carried on in the pages of the *Cahiers du Cinéma*, was a classic problem of the avant-garde: how is it possible – using the same media technology which the establishment uses to install and maintain its hegemony – to create media processes or products that relativize this hegemony or even go beyond it?

Godard's answer was simple but difficult to put into practice – and still is. It does not suffice to use different locations, stories, music, actors, etc., and leave the old film as it is. If one really wants to make *other* films, in the sense of a different idea of society, this must penetrate and reconfigure what Baudry termed the 'basic apparatus.' From the construction of narrative to the choice of film material, the recordings made by camera and microphone, cut and montage, to the re-recording of the film, the *other* ideas must be followed. The greatest challenge of all is to develop optimally the enormous illusion power of film while not taking away from the cinema-goer the feeling and the awareness that he/she is confronted by an artificial world built by technology. Cinema-goers should retain the possibility of deciding for themselves how far they are prepared to get involved with the staged reality on the screen and coming through the loud-speakers. Parallel to this debate and afterwards, film-makers experimented with extreme camera angles, technical breaks in continuity like the jump-cut, the inclusion of the film-making process in the realization, multi-perspective narrative forms, the development of new genres like the essay film, the activation of electronic video technology for film, and much more besides. It was not only the forms of expression of film that were expanded. Many innovations and crazy ideas made an entrance – also as aesthetic attractions – into the center of audiovisual production and distribution: established cinema; advertising, particularly the TV music channels; and more recently the computer. While Perry Hoberman's installation *Timetable* was being exhibited for the first time in Europe at Basel's Viper Festival in 2000, at the same time a competition was running for screensavers. It was as though one had inadvertently walked in on a festival retrospective for experimental short films of the last decades.

In the artistic theory and praxis of advanced media, a discussion comparable to the Apparatus Debate has not yet taken place. With regard to computer-centered production, there are at best very rudimentary beginnings, comparable to the point in film history when, through the direct processing of the surface material, film-makers demonstrated that their projections were designed and formed worlds. Without doubt, it has become even more difficult to do the simple thing with computer-based technology. With regard to representation and immersion, per-formance has become incredibly high, both visually and acoustically; technical interfaces get

closer and closer to the body or penetrate it, so that the senses are more accessible to simulation and manipulation; various modes of action *vis-à-vis* programmed worlds produce, at least on the pleasant surface, the feeling that they are in general producible and controllable. In addition, indefatigable propagandists of artificial life in the natural and engineering sciences contribute to the fact that trust in the technical solution of existential problems is not exactly diminishing, and the first forms of Psychopathia Medialis[7] – obsessive attitudes, also involving suffering, with regard to media artifacts and systems – are spreading nicely.

For me, this is the secret of Perry Hoberman's artistic media work. It is a virtuoso performance on the keyboards and operating systems provided by the telematic industries. Moreover, he succeeds repeatedly in installing a gesture in his works that I really have to call *epic*. Without a doubt, his work is complex. Unfortunately, the term 'complexity' has been worked to death in media discourse; therefore, I prefer to describe Perry Hoberman's work as charged with tension. There are encounters between elements which are, on the surface, irreconcilably different. Advanced technology meets trash (for example, brilliantly in *Faraday's Garden* (1990–1994), where, imagining a sophisticated and extended computer-driven installation, instead, one is led through a vast collection of mechanically moving technical junk). The creation of illusion and alienation is directly meshed. His subjects and image worlds are taken frequently from pop culture and, in museums or galleries, confronted with luxurious dimensions. Most importantly, Hoberman refrains completely from gestures of grandeur found in so many contemporary works and artists,from Bill Viola to Douglas Gordon. It is much more difficult not to use the power one possesses than to attain it in the first place. Hoberman declines to overwhelm. A mischievous smile plays on his lips as he unpacks his filigree building blocks of computer hardware, clever programs, and archaic interfaces. And one leaves his installations with a smile on one's face. This is a rather rare occurrence for what has been called now, for over a decade, with strategic heaviness and calculation, 'media art.'

In this sense, *Workaholic*, an installation developed for the 2000 Ruhr Vision Festival in Dortmund, is typically Hoberman. Since the Renaissance, the pendulum has been the quintessential symbol of the (time) machine. The weight at the bottom of the vertical arm, which appears to move endlessly back and forth from a central point, is, in this case, a scanner equipped with a laser that can move in all directions of the compass. It scans a circular carpet made of hundreds of bar codes, those black and white patterns of lines adorning every article in a supermarket, like supersignifiers of the products' exchange value, which can only be read by machines. The work done by the tireless scanner is image work. According to which bar codes are scanned in which sequence, graphic fragments and sequences are activated in a G4 computer and projected from high above on the white background of the bar codes carpet. However, the pendulum does not move of its own volition. It requires the visitors to intervene so that it may do its work, and this is dramatized

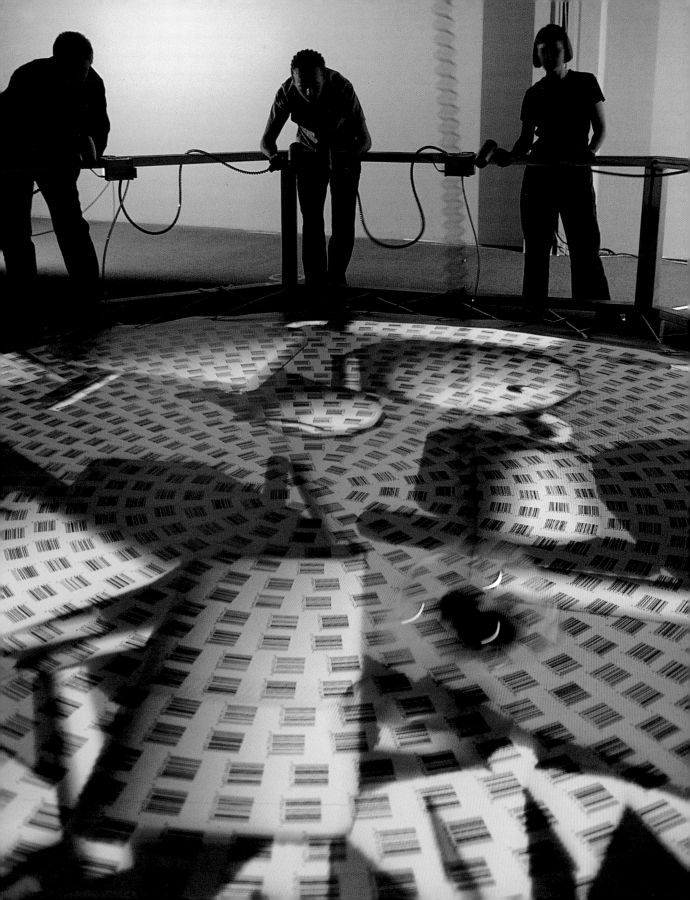

by Hoberman. A railing in the form of an octagon surrounds the carpet. On each of the eight sides, there is an air gun which looks rather like a hair-dryer. With the help of the hair-dryers, the visitors become activists and direct the movements of the scanner, yet only to a limited extent, for the bar-code scanner reactions are delayed, as in a trance. It swings regularly for only one of the activists at the railing. If several air guns are in use, it begins to describe dynamic curves or turbulent trajectories which influence the images produced. The principles are not easy to comprehend. In my perception, these are processes familiar to us from machine production, but also from dream work: shifts, separations, dissolves, erasures, chain formation. Foreseeability often appears to be minimal. The image production also seems to be governed by its own (programmed) laws. If the participants agree on a collective action, the pendulum can be kept vibrating in a resting position at the center, which corresponds approximately to the starting position of the installation. The mechanical and digital systems come together, in neutral, while the players are in a state of hyperactivity. This is not easy to achieve, but it is worth trying.

In his introduction to the *Short Organon*, Bertolt Brecht wrote: 'Let us cause general dismay by revoking our decision to leave the domain of the merely pleasant, and even more general dismay by announcing our decision to take up residence there. Let us treat the theatre as a place of entertainment, as is proper in an aesthetic discussion, and try to discover which type of entertainment suits us best.' Perry Hoberman helps us try – in museums, in galleries, in the spaces in between.

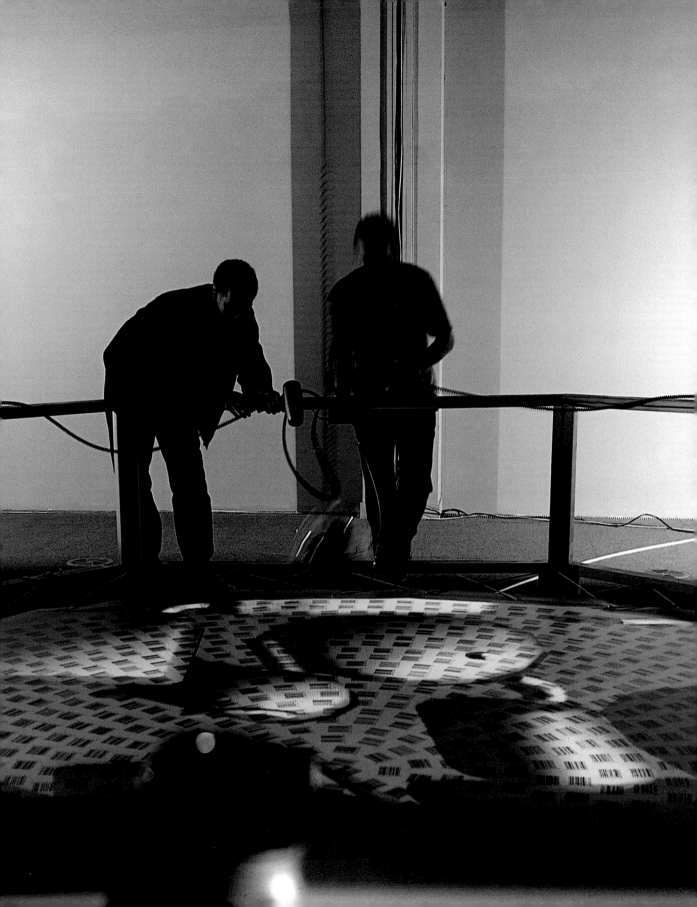

Notes

1

I am referring to the two well-known and great founding works for artistic praxis with and by media: Giovan Battista della Porta's *Magia Naturalis* of 1558 and Athanasius Kircher's *Ars Magna Lucis et Umbrae*, first published in Rome in 1646.

2

In the catalogue *Unexpected Obstacles – The Work of Perry Hoberman 1982 – 1997*, Galleria Otso, Finland, 1997, pp. 24, 25.

3

A Nous La Liberté and Entr'acte, films by René Clair. English translation and description of the action by Richard Jacques and Nicola Hayden, in the Classic Film Scripts Series, Lorrimer, London, 1970, p. 93.

4

Ibid, p. 9.

5

It is not possible to tell the stories of both films here. The tramp, the outsider who is totally unsuited to production-line work and strolls through life with a free and easy attitude that conflicts with social norms, plays a decisive role in both films. Approximately at the same time, Georges Bataille wrote a seminal essay, on which he based his later *Abolition of the Economy*, with the title 'La notion de dépense' ('The notion of expenditure'), in *La Critique Sociale*, No. 7, January 1933. In this economic design, which was levelled at the productivity mania of both capitalists and communists, the *clochard* who sleeps rough under the bridge assumes an important metaphorical meaning for this attitude, which simply wastes accumulated surplus value through unproductivity.

6

See N. Röller and S. Zielinski: 'On the difficulty to think twofold in one,' in *Sciences of the Interface*, H.H. Diebner, T. Druckrey, and P. Weibel (eds), Genista Verlag, Tübingen, p. 283ff.

7

This is a reference to a key work of the nineteenth century, Krafft-Ebing's *Psychopathia Sexualis*, which continued to be reprinted into the twentieth century and had a profound influence on the Surrealists, among many others. The book treats in great detail (partly in the scientists' code of Latin) sexual dispositions and acts that were classified by Krafft-Ebing and his contemporaries as deviant; in particular, masturbation, homosexuality, and fetishism. These phenomena, which have always existed, were dragged into the spotlight of scientific discourse under the pressure that industrialization exerted on the human body and psyche.

Translated by Gloria Custance

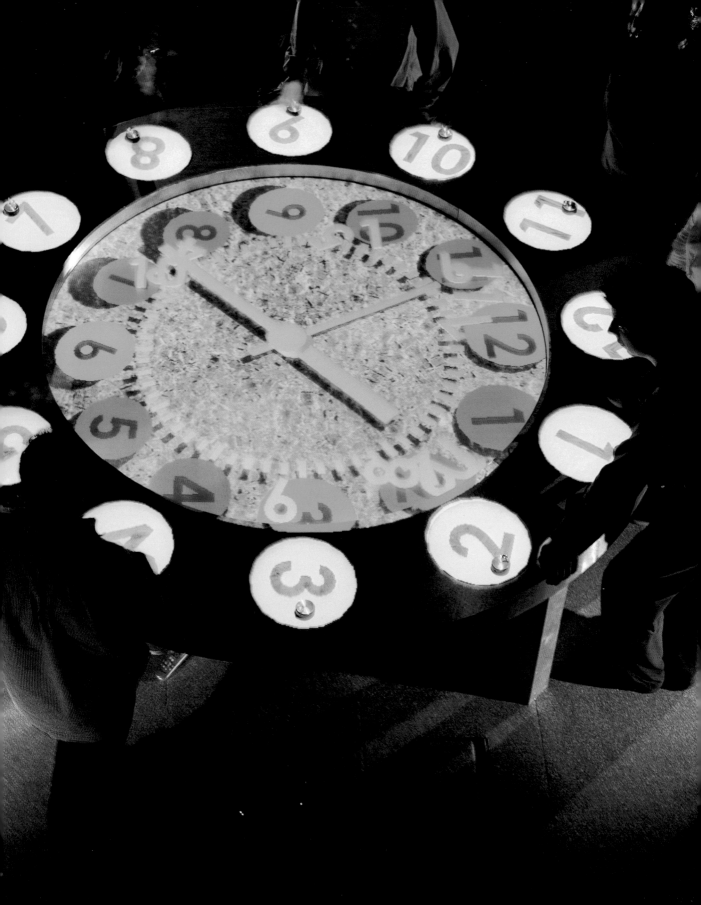

The *Deference* Engine:
Perry Hoberman's Unruly Tur(n)ing Test

Timothy Druckrey

The Engine will always reject a wrong card by continually ringing a loud bell and stopping itself until supplied with the precise intellectual food it demands – Charles Babbage

The engineering of intelligent machines remains the holy grail of the technosciences that have burgeoned since Babbage's calculating machines. The drive to construct a sentient, anticipatory, and ultimately autonomous apparatus remains largely conjecture, despite the much hyped 'defeat of humanity' that came with Kasparov's 'loss' to IBM's silicon chess whiz Big Blue, despite the continuing slather of speculation from the hyperbolists of AI (from Minsky to Moravec), despite, even, the infantilized version of sentient being in Spielberg's abysmal oedipization of the Turing Test in the Hollywood version of whatever film Kubrick had in mind for *A.I.*

In some ways little has changed since Babbage's time, and even Spielberg's little David, the affably inane (that's AI) creation of some kind of fairytalized cross between ET and HAL, ends up in the automaton ER after the preposterous bot ingests some decisively 'imprecise' spinach while learning that humans suffer from 'cybling' rivalries. Cyborgs, after all, can be programmed to express artificial love, but damned if they can eat. Nevertheless, the clawing proponents of AI and the sycophants of cyborg sentience can't but crow at the attempted humanization of little David's endearing persistence to bond with a remarkably enduring theme-park madonna, sunken, for just a few short frozen millennia, in what was once Coney Island. In the end, of course, we haven't gotten very far if the best this fake little circuit-board kid can do is pine for a virtual version of mommy. David's problem, after all, is that he cannot age, that he was always frozen in time, unable, because of the flaws of the maudlin fantasies of his creators, to do more than fulfill the lost realities of others with aimless repetition.

So much of the research and development in scientific and technical culture is riveted by reproducibility, by the 'dilemmas posed by our skill at the creations of likenesses of ourselves, our world, our times' (as Hillel Schwartz writes)[1] that the engineering of opposition or of truly other worlds is lost in the industry of cybercops, in pubescently desirable game babes, or in the resurrection of the lost world of dinosaurs. Have we forgotten the history of the fanatical scientist's creations from Frankenstein to Maria or from Terminator to Lara Croft? Obviously.

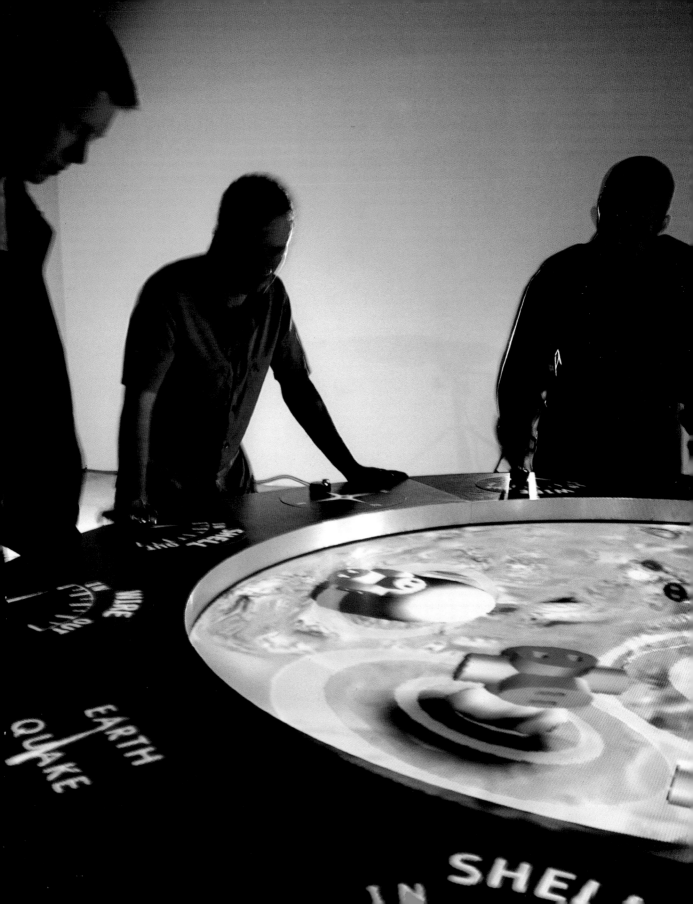

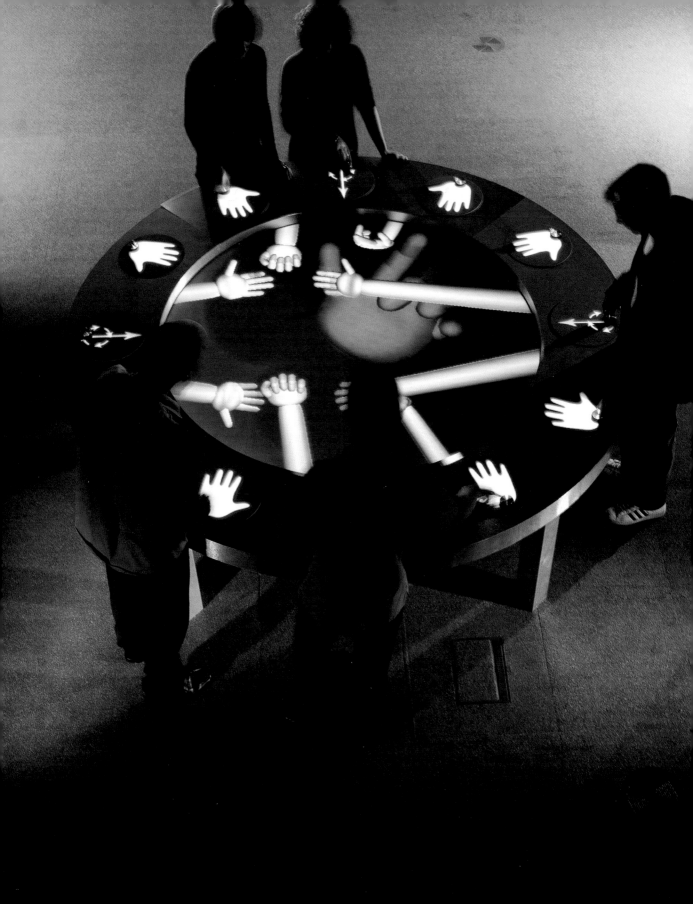

But the unwillingness (or refusal) to think through the relationship between our apparatuses of imagination and the technologies used in their implementation is a failing that sustains itself in many fields.

And while much of the last century celebrated the mechanization of the world as a triumph of ingenuity and science, the legacy has proved less than reliable as a measure of humanity's liberation from the niggling tribulations of totalitarianism, war, nuclear misfortune, stubborn environmental devastation, demoralizing working conditions, cold peace, deterrence, multi-national cyber-capital, and a few other of the quotidian benefits of engineering. But the last century was also compulsively investigating deeper mysteries than those of hard, physical reality. As quickly as it was transforming and mastering the hard world of materials, it began an investigation of the softer worlds of the structure of matter, the agencies of the infinitesimal, the intricacies of probability, the biologies of life, the activities of consciousness, the calculability of information, the paradoxes of light, and the boundaries of time. It brought us Taylor and Einstein, 'mechanization takes command,' and the 'age of the world-picture,' social realism, and revolutionary avant-gardes, Turing and Chaplin, Weiner and Mcluhan, Minsky and Chomsky, Dennett and Deleuze, Dawkins and Gould, in short, a series of oppositions that characterize the relationship between determinism and probability, master(ed) narrative and contingent accounts, authority and resistance, banality and creativity.

Most insistent throughout the century was an ongoing assessment of space–time, one that extended from Bergson through Deleuze, from Einstein's relativity to Everett's 'many worlds,' from cubism to virtual reality, from Futurism to Glitch, from absolute to post-linear narrative, from cinema to immersion, from Mach to Virilio; the list goes on and on. Suffice to say, that the clockwork universe was countered by the metaphor of, as Einstein suggested, 'a clock at every point in space,' a sphere in which events (or their horizons) were no longer regulated by simple causality but by complex interactions, by variability, by 'uncertainty,' even by the toppling of so-called 'common sense.' In these complex new systems, trajectories uprooted singularities, inertia moved, the image was potentialized, space was not absolute, time was unfixed, reality, like subjectivity, was a variable, experience was a transformation. In each field, the confrontation with the representation of temporality found metaphors in 'duration,' in multi-spatial representations, in the 'intermovemental,' in speed, or in the investigation of micro-temporalities of sound, in the temporal cuts of cinema, stream of consciousness, or in the paradoxes of time in quantum physics.

Time and machines, time and capital, time as capital, 'time and free-will,' 'being and time,' 'the time-image,' 'speed and politics' are but hints at the scope of approaches that looked at the shifting temporalities (and their implications). So much of the last century was riveted by mechanics and temporality that it is breathtaking. It doesn't take much to understand that the twentieth century's relationship with temporality underscored its craving for acceleration

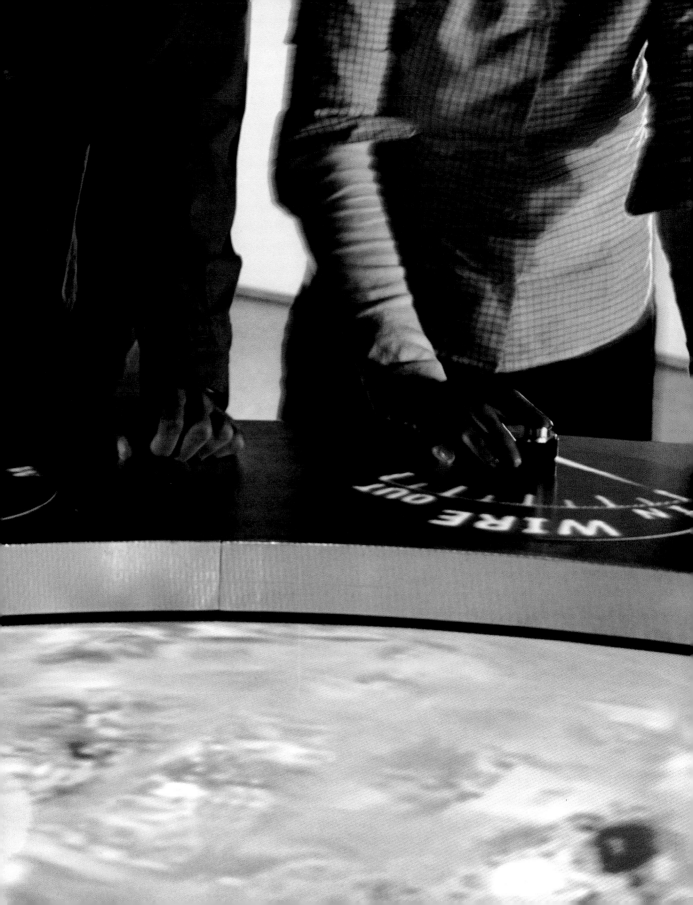

and power. In the arts, these issues were decisively raised and the stages from chronophoto-graphic through cinematic and electronic temporalities remain both decisive and largely unwritten, but not wholly ignored. In the rethinking of time in the light of science and media, it is clear that a number of approaches emerge that link reflection, perception and intervention to both the subject itself as well as the subjectivities that reside within.

Yet beneath the subjectification of time, 'the visible forms of time,' as Peter Weibel writes in 'Chronocracy,' 'chronological time, historical time, and natural time ... are past and gone.' Replacing them is 'the techno-time of the electronic media ... now the legitimate artistic form.' In this framework, he continues, 'the electronic media articulate the simul-time of the new feudal society, its character as a place defined by the borrowing and granting of time, for, in place of the spatial depths of classical visual representation, the electronic screen is capable of imaging the virtually infinite depth of time, capitalism's apparently inexhaustible resource.'[2]

Perry Hoberman's *Timetable* in a direct way confronts this economy of time without the burden of the infinite, but by implementing and distributing the regulation of the work to the twelve controls that ring the projection. '*Timetable* is an attempt to play with concepts of time – to buy time and to spend it, to save time and to waste it, to find time and to lose it, to borrow it, to run out of it, to kill it.' Timetable proposes a time released from monotonous utility, liberated from relentless cycles as it relativizes both its ceaseless regularity and its potential as an interface. The time of *Timetable* is subversive, unstable, asynchronous, and ultimately destructive. Users rotate small dials and implement actions in the sometimes swirling, sometimes aggressive, sometimes collaborative, sometimes pointless, sometimes rigorous, sometimes decelerated, sometimes accelerated, 'real-time' in which Heisenberg's Uncertainty Principle joins Turing's Test in a projected electronic cauldron of ambiguous observers, uncertain agencies, programmed ambiguities, elicited cooperations, nonsensical interventions, indeterminate identities, indefinite consequences, and inexact chronometry.

Thus Hoberman describes *Timetable* as 'a kind of giant immersive clock [that] could as easily be described as a board game without rules, a top-level meeting with no agenda, or a séance without spirits.' In this sense, *Timetable* evokes all sorts of references to comforting non-hierarchical circular forms, the campfire, the knight's round table, negotiation tables, conference tables, intimate dining tables, the café, etc., while its central screen conjures consequences from the events that take place on its periphery. And while the teamwork (or possible teamwork) of its users establishes momentary alliances, its behavior is essentially alogical, not rewarding of an expectation of continuing transformation, not empowering of the realization of its performance – since it will not repeat. Everything, like every moment, is up for grabs. It doesn't calculate differences (like Babbage's engine), rather its sequences of actions are accomplished in deference to the intentionalities of its users.

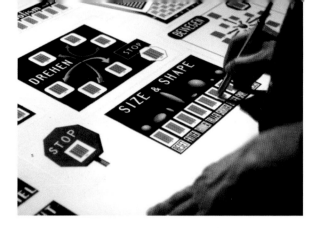

Bar Code Hotel 1994

As is obviously the case with a number of his earlier works (*Faraday's Garden, Bar Code Hotel* ...), Hoberman combines a fascination with obsolescence, retrieval, and 'alternative interfaces' with the investigation of technologies that have hardly exhausted either their functional or creative potentials. Indeed, the trajectory of his work since the early 1980s is as much an ongoing encounter with technologies whose sheer presence is far too easily overshadowed by disquieting conceptions of transparency and invisibility as it is an instinctively reasoned – even methodical – deconstruction of the illusions (in the broadest sense) of a culture inebriated by the surface, narratives, tropes and intersections between Hollywood cinema, the (im)plausibilities of science (and its fictions), tele-supremacy, the often stunning announcements and spectacles of technological research. But rather than peeling away the often depthless ideologies of media, Hoberman's work scrutinizes and allegorizes issues that are at the center of the discourses of technoculture.

This resolute irreverence explains his fascination with 'misbehavior.' His essay 'Mistakes and Misbehavior: Tantrums in/Tampering with Cyberspace' maps out an approach in which expectation is linked with the shattering of the normalized routines of cause and effect. He writes:

> Is it possible to break something inside of a virtual environment without thereby causing an immediate rupture in the illusion/immersion? How much must we restrict our actions inside of these artificial realities? And if these worlds are in fact as fragile as they appear, might there be some way to make them more pliable, more resilient? How can limits be tested in this arena without causing the entire edifice to come crashing down? Do the rules for any such breakage have to be programmed? And does this necessity preclude the possibility of unpredictable accidents?
>
> ...
>
> Simulation technologies were originally developed to allow soldiers and pilots to experience dangerous situations without mortal consequences, to survive what would in reality be a fatal mistake. In applying this apparatus to less instrumental

tasks, can't the sphere of possible mistakes and misbehavior be widened? Shouldn't we be able to misbehave ourselves in cyberspace? Or are we going to condemn ourselves to tamper-resistant worlds that are as controlled and predictable as any shopping mall? Instead of modeling behavior, I want to focus on misbehavior; not the cooperative response but the unexpected one; not the enthusiast but the iconoclast.

Hoberman also describes *Timetable* as an attempt 'to make certain paradoxical (even impossible) pseudo-scientific concepts into concrete experiences, such as time travel, multiple branching universes, alternate dimensions and shared hallucinations.' *Timetable* is without doubt linked with Hoberman's unambiguous fascination with the looming and pervasive tropes of pop culture, pulp fiction, science fiction, fictional science, cybermania, and a generation of rootless (should I say 'rhizomatic') electronic 'intellectuals' touting everything from 'digital being' or 'collective intelligence' to 'technoetics' or 'post-humanism' in pretentious forms that, as Hoberman suggests, 'are no barrier to hilarity.' In this sense, Hoberman's parodic interventions into the sacrosanct presumptions touted by the apparatchiks of humanized neuro-hardware or virtualized epistemology are deeply serious, and played out by joining defiantly anti-behaviorist strategies with an incisive understanding of the possibilities of an interactivity whose reach into the public sphere is both willing and playful.

In the end, *Timetable* is an exemplary Hoberman work. As much open-system as closed-circuit, *Timetable* is 'time out of joint,' time that is located in the rationality of the table-sized dial but whose face is exploding with conflict, with competition, with incompleteness. In opening the face of the 'clock' to the interruptions of its users, it reveals the game of time as an exercise in futility. But more than this, *Timetable* provokes a series of reflections on our compulsion to take command of the clock, to consider time's origin, and its contradictions, to conceptualize time as deeply embedded in the human predicament.

Bernard Stiegler concludes the first volume of *Technics and Time* with the following:

> Today memory is the object of an industrial exploitation that is also a war of speed: from the computer to program industries in general, via the cognitive sciences, the technics of virtual reality and telepresence together with the biotechnologies, from the media event to the event of technicized life, via the interactive events that make up computer real time, new conditions of event-ization have been put in place that characterize what we have called light-time.

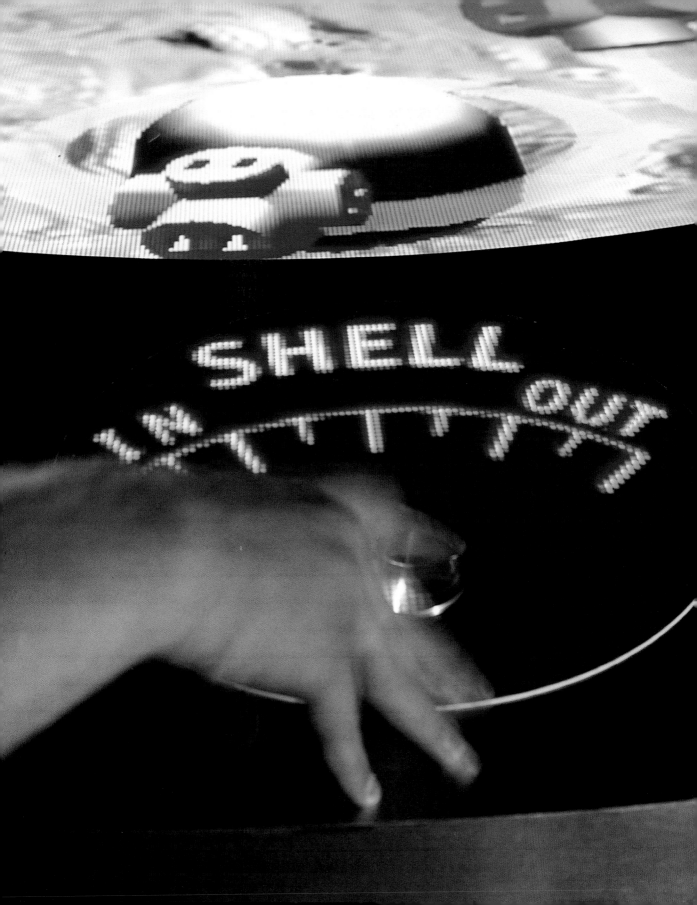

Light-time forms the age of the différence in real time, an exit from the deferred time specific to the history of being that seems to constitute a concealing of différence and a threat to all kinds of difference – which is why one can speak of the end of history or of a change of epoch. Today this light-time raises demands for *exceptional* measures: hence 'the cultural exception.' There is therefore a pressing need for a politics of memory. This politics would be nothing but a thinking of technics (of the unthought, of the immemorial) that would take into consideration the *reflexivity* informing every orthothetic form insofar as it does nothing but call for a reflection on the originary default origin, however incommensurable such a reflexivity is (since it is nonsubjective). Whence the excess of measure in this exceptional phrase inscribed on the wall of time: *no future.*[3]

© Timothy Druckrey

Notes

1
Hillel Schwartz, *The Culture of the Copy: Striking Likenesses, Unreasonable Facsimiles*, Zone Books, Cambridge, 1996, p. 11.

2
Peter Weibel, 'Chronocracy,' in *Machine Times*, Joke Brouwer and V2_Organisation (eds), NAI/V2,Rotterdam, 2000, p. 167.

3
Bernard Stiegler, *Technics and Time, 1: The Fault of Epimetheus*, Stanford University Press, 1998, p. 276.

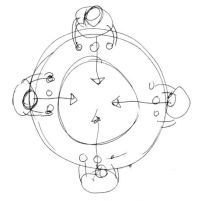

DIALS: AFFECTED DIRECTLY BY USER
INDIRECTLY BY OTHER USER'S ACTIONS
(CAN TURN AUTOMATICALLY)

TURNS - CONNECTIONS -

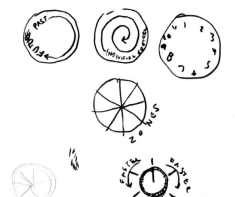

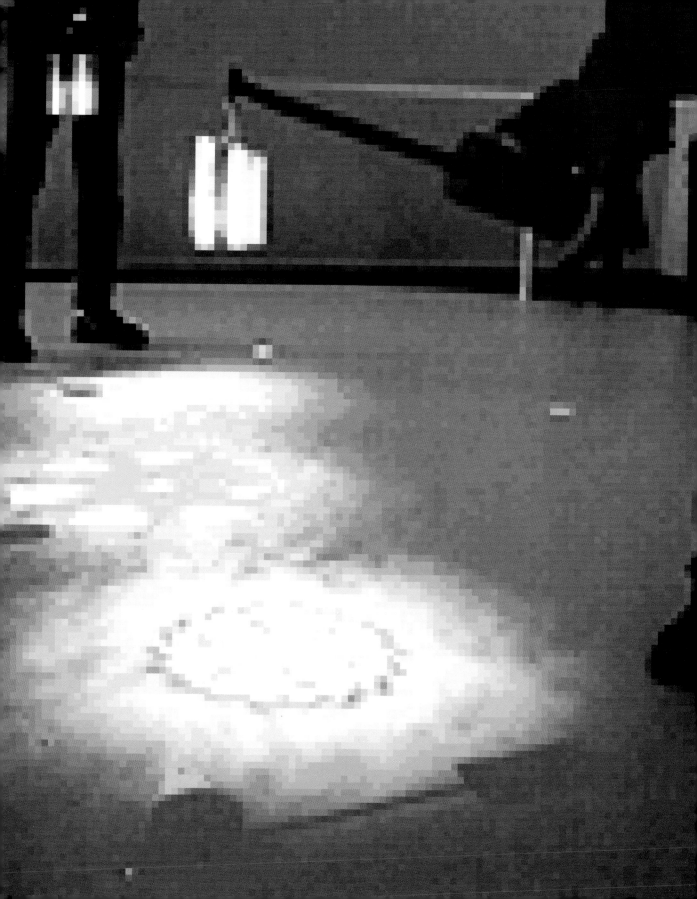

Still Misbehaving:
Perry Hoberman's Medium-Tech,
High-Fi Exorcism of Technoculture

Christian Viveros-Fauné

So you've got a 6:00 PM flight out of La Guardia arriving Heathrow at 5:30 in the morning.

You've packed your 225 volt adapter plugs, a brand-name all-purpose suit, some bright shirts, a date-book (you don't yet own a PalmPilot), new off-the-rack magazines, a softcover volume on 'privatizing art and culture.' By the time the taxi arrives downstairs, you've efficiently zipped your laptop into its carrier, double-checked your flight information, patted your inside jacket pocket for your ticket and passport, begun to gradually disengage from the daily routine.

The headphones go on somewhere between home and the arrivals terminal. The Discman blares a new CD lifted from the 'Imports' rack of your neighborhood megastore. An eclectic wall of sound mixed from other sounds, it starts out spikily, then coalesces into the expected: pure soma. You bob your head. As the cab moves to deposit your stuff curbside, you motion towards an identifying plastic sign. It bears the same red and white logo as the megastore.

The flight itself is eventful only in the variety of distractions that are proffered. Newspapers are available in every major language; pop-up menus of video games, music videos, familiar sitcoms and studio films appear on one's own private mini-screen; alcohol, a much older entertainment technology, is served in seemingly limitless quantities. You take in the CBS *and* the BBC News, *Who Wants To Be a Millionaire*, a movie with Martin Lawrence, an international soccer digest, an episode of *Mad About You*, half a documentary on Richard Branson's ballooning feats; you scan the Teletubbies.

Sated and woozy, you emerge from the plane's fuselage after six transatlantic hours, tired, unfazed, unchanged. Disembarking proves the usual chore. You follow the signs: rest rooms, baggage claim, change bureau, a monitor cycling an advertisement for British Telecom. When the customs agent greets you, you conjure up, from the deep well of aleatory information that is your brain, a few familiar images and sounds. You think of Michael York or Michael Caine, even of an American actor playing a part. You're here. He's here. You have, after all, seen it all before.

'Our time consumes much more reality than it produces,' Spanish artist Perejaume once told an interlocutor. 'Consumption and technology appear to have become allies in a voracious

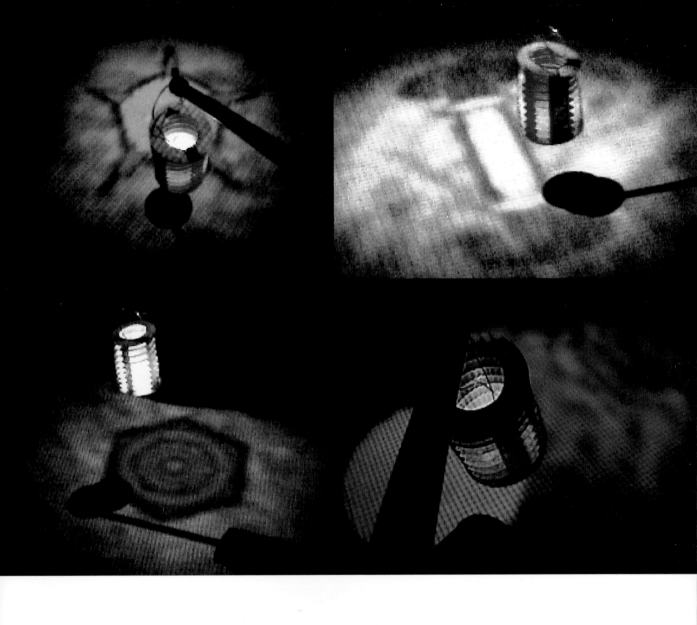

620

6M

1M

1← 5CM ∅

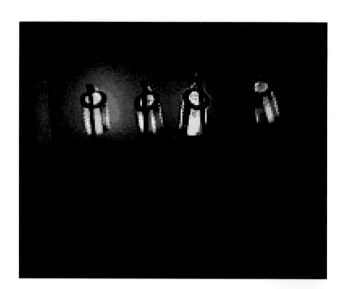

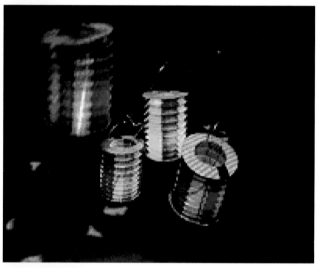

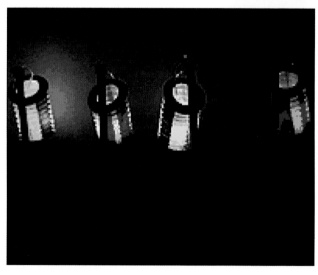

sacking of reality, of the images of reality and, especially, of the reality of images.' However sophisticated one's understanding of the relations between reality and make-believe, the experience of having fiction – in the form of mediatized images and sounds – anticipate or reinforce mundane reality can prove at once oddly disconcerting and tremendously reassuring.

One effect of what academics admiringly point to as a worldwide landscape of simulation, this sort of '*déjà vu* all over again' (to use baseball legend Yogi Berra's famous malapropism) underlines once again the glut of familiar, proliferating signposts the world is filled with. To the miles of endless, meaningless roadway signage Jean Baudrillard alternately decried and rhapsodized about in his 1989 book *America*, there have been added millions upon millions of virtual miles in the form of ever newer products, 'cutting-edge' technologies and the World Wide Web. Stepping up their cultural production and turning away from the manufacture of traditional goods, corporations in the US and other Western countries have filled the world to the brim with an increasingly globalized kind of entertainment and 'information.'

Consisting of an ever larger flood of gadgets, shrinking computers, software packages, electronic games, compact disks, digital movies, interactive technologies, millions of other leisure products and their ubiquitous, enveloping advertisements, our everyday environment resembles nothing so much as a crackling, strangely comforting media haze. Continual restatements of consumer passivity, these signs activate desire only to plummet it and its subjects back into a bedrock status quo cemented by the interests of increasingly cagey, ultra-hip corporations. You need only think of Sprint's commercial use of the Rolling Stones' song *Time Is On My Side* or Apple's *Think Different* billboards with images of John Lennon and Gandhi to obtain a sense of what writer Thomas Frank has so accurately pegged as 'the conquest of cool.'

Ultimately, the idiom of advertising has created enormous new gaps in the mechanisms of language, effectively demolishing its denotative as well as its communal and ethical functions. In its use of an extraordinary repertoire of resources, signs and literary figures, in its banalization and exhaustion of all sort of metaphoric and metonymic procedures, the marriage of consumption and technology has soured language, turning its signs from functional and meaningful messages to obvious and repetitive displays of inexhaustible promotion. Thus the age of Technoculture, our own age, boasts an image bank as vast as it is pedestrian. After having supplanted a largely religious and secular-scientific image bank, it malingers there statically, an *imaginaire* virtually larger than the great outdoors, generating ever more images without engendering to date any sort of conflict.

Legitimized by the syllogistic, absolutist yet fashionable formulations of Baudrillard, academics, critics, writers and artists have largely capitulated to the banal discourse of the mass media. Complacently taking reality to be *only and exclusively* an expanding grid of self-referential 'signifiers,' artists like Jeff Koons and Peter Halley have understood the replacement

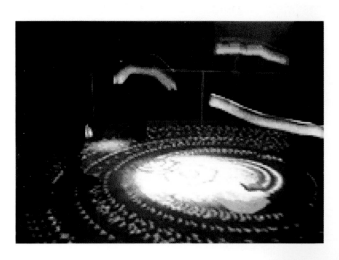

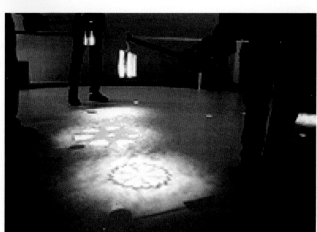

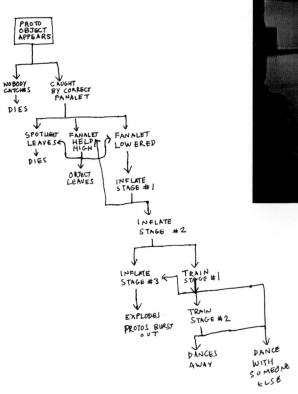

PROTO
OBJECT
APPEARS

NOBODY
CATCHES

DIES

CAUGHT
BY CORRECT
FANALET

SPOTLIGHT
LEAVES

DIES

FANALET
HELD
HIGH

OBJECT
LEAVES

FANALET
LOWERED

INFLATE
STAGE #1

INFLATE
STAGE #2

INFLATE
STAGE #3

TRAIN
STAGE #1

EXPLODES
PROTOS BURST
OUT

TRAIN
STAGE #2

DANCES
AWAY

DANCE
WITH
SOMEONE
ELSE

of reality by simulacra to mean a wholesale endorsement of market forces, commodity art and a blanket denial of all authenticity. 'Simulation envelops the whole edifice of representation as itself a simulacrum,' Baudrillard has written, negating the existence of any countermanding values or meanings in the world. Put better and without the jargon by *New Yorker* critic Louis Menand, Baudrillard's 'hyperrealist' fantasy might read in the following manner: 'In a consumer society, the new thing must be different from the old thing. Beyond that, there is no requirement, and no deeper pattern is knowable.'

For many contemporary artists, particularly for those presently working at the outer edges of our technological culture, Baudrillard's overheated, courtier-like vision functions as the ultimate rationale for co-optation by certain expanding, seemingly unstoppable market forces. Reveling in an overload of mass culture, in its seemingly uncontrollable explosion and relativization of signs and messages, their work repeats the old, affectless cliché about simulation – that it envelops reality like a blanket and replaces it, that the world as we know it is reducible to Disney World, that authenticity is now and for ever buried beneath a thicket of autonomous simulacra – negating in the process the need for any imaginative or critical transcendence.

One artist who certainly sees things differently is Perry Hoberman. Committed to a rowdy, misbehaving view of art, culture and technology, Hoberman constructs interactive installations and sculptures with a variety of media, looking to simultaneously expose the seams built into his various materials, their interactive possibilities as well as their myriad, often conflicting, messages. Working with obsolete or low-tech stuff (electrical as opposed to electronic parts, things analog or mechanical) and high-tech gadgetry (the latest computers, newest software programs or state of the art virtual reality displays), Hoberman has arrived at a coinage that is equal parts a working method and a shifting, contingent but expressive artistic ethic: 'medium tech.'

In observing the fetishizing tendencies of both low and high tech media – the first fetishizes technology in an archeological manner, the second through a slick, highly commodified futurism – Hoberman has considered the rapidly changing nature of our perception of technology itself. 'Due to some inexorable process,' Hoberman says, 'yesterday's high tech becomes today's low tech. On the way there it passes through a phase I call medium tech: it's been around for long enough that it's stopped impressing anyone, but hasn't yet started to inspire nostalgia.'

Hoberman is thinking here of bar codes, slide projectors, answering machines, radios, VCRs, burglar alarms and other such objects, the principal characteristic of devices such as these being that they've become utterly prosaic after widespread use. Neither too cheap nor too expensive, they avoid both the cool of designer store displays and yard-sale quaintness. Together with newer and older media, Hoberman's use of medium-tech materials in his sculptures and

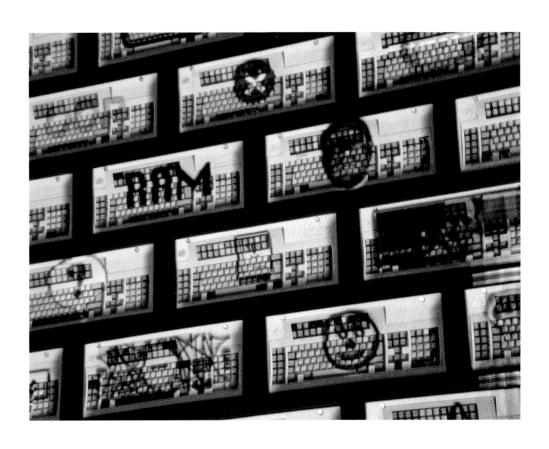

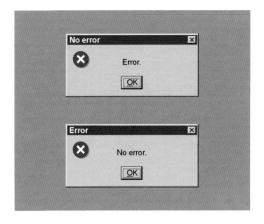

Cathartic User Interface 1995/2000

installations hybridizes technology into a graspable, unintimidating continuum, promoting at once a rare user-friendliness and a novel 'technologically incorrect' approach towards accepted commercial and artistic modes of employing technology and interactivity. Hoberman purposefully frustrates the gee-whiz expectations built into the reception of so-called 'new media art'; his mix-and-match approach demystifies technology, opening up, in his words, 'other areas of resonance, other possibilities for expression.'

Called 'the world's foremost appliance artist' and 'an archeologist of consumerism,' Hoberman is at his most engaging when challenging everyday technological environments. In the work *Cathartic User Interface* (a collaboration with Nick Phillip) Hoberman fashions a wall of old keyboards at which multiple participants are invited to throw Koosh balls. Aiming at moving projections of deliberately tweaked computer logos, from an Apple brand symbol to a portrait of Bill Gates, the participants 'quickly and effectively work through their conflicting emotions concerning the benevolent yet pernicious influences of computer technology on their lives.' Designed to feature sounds akin to those produced by digital toys like Sega Gameboy, and announcements such as 'You have no new mail, you have no friends, you have no life,' Hoberman also includes a return ramp for 'maximum cathartic effect.'

No mere one-dimensional bashing of technology, *Cathartic User Interface* presents actual conflicts between computers and their users in the guise of a funhouse shooting gallery. Avoiding direct political statements, exhaustive critiques and neo-Luddite formulations, Hoberman places his work at a humorous, ambiguous remove that accentuates the installation's ludicrous properties. As the *ludi publici* were once the public games of Roman antiquity, so Hoberman invents a twenty-first-century interactive game for a public presumably fed up with the pressures of technocultural modernity. Baited by questions such as 'Are you a MERE DRONE in the ever-expanding DIGITAL WORKPLACE?' and 'DO YOU YEARN for release from an OBSESSIVE LOVE-HATE RELATIONSHIP with TECHNOLOGY?' the participants in *Cathartic User Interface* seek and obtain release from the weight of mundanity not through Aristotelian catharsis (achieved by tragedy 'through pity and fear effecting a catharsis of these emotions') but through the sympathy elicited by the incongruous and the comic. (Note: *Cathartic User Interface* is, after all, making fun of a supposedly intelligent environment.)

Constructed social spaces where relations between computers and their users are experienced on a basis more complex than one-to-one; medium-tech worlds that veer technologies away from their original purposes; interventions and misemployments of technocultural myths (like those who imagine that technology provides for a truly global culture, inaugurates an age of infinite creative possibilities, and eradicates discrimination on the basis of gender, race or class); the embrace of the accidental and provisional aspects of interactivity. These are the strategies Hoberman deploys in his pointed querying of technoculture, its compelling and coercive images,

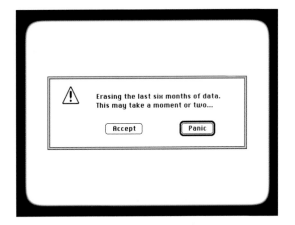

and our increasingly passive relationship to both. On the issue of consumerist passivity and how it shapes our experience of technology, Hoberman is clearly on the side of the disruptive: 'Instead of modeling behavior, I want to focus on misbehavior; not the cooperative response but the unexpected one; not the enthusiast but the iconoclast.' His method challenges 'the assumption that users are going to do exactly what you tell them to do.' As he knows very well, very often they don't.

Above all, Hoberman the artist is concerned with seriously frustrating the expectations built into a continually fluctuating yet persistently generic notion of new media. Like much new media, interactive technology continues to be designed for a single user, requires that user to remain immobile, and is years away from reaching the immersive experience it so brazenly advertises. Riffing on ideas of the social as an entry point for achieving interactivity with multiple subjects, as a pathway for *son et lumière* total atmospherics, and as a communal method for experiencing what he calls 'casual or open-ended interactivity,' Hoberman designed, together with Galeria Virtual (Narcís Parés and Roc Parés) *El Ball del Fanalet (Lightpools)*, a complex, immersive installation that poetically updates an older collective experience by means of a new audiovisual environment.

Exhibited at Barcelona's Fundació Joán Miró in 1998, *El Ball del Fanalet* was designed as a virtual reality installation to be experienced by multiple participants simultaneously. Using paper lanterns (or *fanalets*, typical of a once-popular Catalan *ball* or dance) fitted with small battery-powered bulbs and wireless sensors, a computer to read the position and actions of

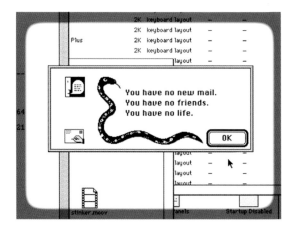

the participants, and floor projections which appear to virtually emanate from the lanterns themselves, the installation provides a digitally generated, ballroom-like experience in which people can perform in real time.

Fully activated by the collaboration of various participants, *El Ball del Fanalet* is extremely successful in evoking the physical reality of the regional dance from which it draws its title. A Catalan dance once performed in the popular dance halls in and around Barcelona, the *Ball del Fanalet* required the male partner to hold aloft a *fanalet* while dancing a waltz. As air currents blew out the candles that illuminated the *fanalets*, couples left the floor until a last winning couple remained. Scored with an ambient soundtrack of fifties' ballroom music augmented by vast quantities of distant-sounding reverberation, Hoberman's and Galeria Virtual's version of this popular social ritual keys not only into the poetics of real versus virtual space, but also investigates the shifting terrains of locale and history, individuality and collectivity, actuality and memory.

Allegorizing new artistic and experiential possibilities through ingenious, novel uses of technology, Hoberman and Co. make an argument employed by the critic Timothy Druckrey and the pioneering video artists of yesteryear: 'Like it or not, the most cogent users of the media are not its consumers but its producers'. An observation Hoberman would like his audience to intuitively grasp when experiencing one of his complex yet accessible installations, it has animated this artist's migration through the use of various 'cutting-edge' technologies: from analog to video to digital to interactive media.

Now experimenting with media such as virtual reality to arrive at a contingent, mobile sort of cyberhumanism, Hoberman reminds us of our place in a rapidly changing technology-driven culture. Looking to recapture a protagonism ceded to the vast, impersonal forces of the marketplace, he explores and fetches back values and relationships that recently seemed forgotten or even obsolete.

Built into installations and environments like *El Ball del Fanalet* and *Cathartic User Interface* is a set of pointed questions and refusals aimed at both the consumerist forces of technoculture and capitulating simulationism: Are the participative and creative limits of technology fixed and inevitable? Are the banalities of television, Hollywood, advertising, computers, *et al*, truly substitutes for reality or are they merely a convenient science fiction for an ideology of passive consumerism? Shouldn't we be able to subvert and ingeniously sabotage both the legitimated uses and accepted abuses of technology? Or as Hoberman himself puts it: 'Are we going to condemn ourselves to tamper-resistant worlds that are as controlled and predictable as any shopping mall?'

Knowing that the answers to these questions will determine what our lives are made of, Hoberman says yes to reality and to its further technological and virtual expansion.

July 2001

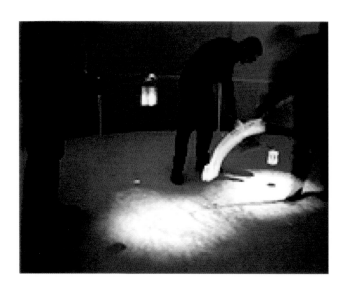

Lightpools 1998

Bar Codes and a Really Clumsy Mouse
A conversation between Natalie Jeremijenko and Perry Hoberman

1. Screens

You've explored many different modes of group interaction with images. Why do these three pieces use down projection, that is, projection from above?

Floor projections allow you to walk into the image, either actually or potentially; the image isn't just a picture on a wall, framed by a screen. These horizontal images warp perspective; it's unusual to see a two-dimensional projection of a three-dimensional space viewed from above. It's like being up in an airplane or looking down on a city from the top of a tall building, but you're up close so you can enter into and interact with the image.

Another thing that happens when you take the screen off the wall and flatten it is that people around it are facing each other, which privileges a certain kind of social interaction.

In a networked situation, everyone essentially faces outward, and in VR you're immersed in a black void in which it's almost arbitrary which way you're facing. Here people face inward. In some ways what I'm doing is very traditional, it's like a board game, like sitting around a table playing Monopoly.

So there are other ways that people can be because of the break from the wall-based screen.

Though it's still a screen space. I have a crackpot theory that it's accidental that pictures ended up on the wall. In any pictorial representation, you give up one dimension, because you're translating from three dimensions to two. And the dimension that got axed was depth. Height and width are physically present, but depth is faked, using perspective and other techniques. If you lay the screen on the floor, you switch to a situation where width and depth are present, but height is left out. So height has to be faked. And we don't have such

familiar techniques for representing height. What you get is a space that might not be good for traditional representation, but that might be a very good way to explore other methods. Usually we only look down at the ground to see where we're going, to navigate.

So you are actually privileging the space, the actual space between people, which is what you're framing and making precious.

Right, instead of a situation where you have the screen at one end and the audience at the other, you have audience/screen/audience. The screen becomes a bridge between people.

2. Perception

The interactive elements of your work seem to have developed into the formal decisions that you've made with these three pieces; there's a kind of scripting of the audience which is very straightforward.

When you build custom hardware interfaces, you have to take into account that they're not the ones that we're used to in the way that we are with mice and keyboards. So if you make it completely aleatory or random, then you're pushing too hard and people will tend to disengage really fast.

I'm curious about what you privilege and underprivilege by setting it up this way.

You lose the certainty that people will always perceive the same thing; they're no longer seeing things from the same angle. Experience isn't going to be shared the way it is when everyone's sitting in front of a screen. And you can't simply watch the image without being at least somewhat aware of what other people are doing. There are any number of works that involve interaction with a traditional screen-based image

in which I think you can still stand back and watch as though you're watching a movie. Here that idea gets completely disposed of. It's a shared image. The fact that it's a circular image gets rid of any explicit up/down orientation. In fact, all these pieces use 2D and 3D coordinate systems, but we've gone to a lot of trouble to orient things radially such that there's no apparent up or down.

You're in a position to communicate with other people, you're facing them, so there becomes something almost conversational about it. It opens up all kinds of possibilities of cooperation, or of forging some sort of relationship.

What's also underprivileged is not only the kind of narrative that you might watch as part of an audience or a single viewer, but also the sense that your actions give you any kind of absolute control over what you're watching. You don't have the kind of control that you might have in an interactive piece that's been designed for a single person. It's always problematic what the result of any action is going to be. Each action is modified by the computing system, which, in an ideal world, would actually be complex enough to make things unpredictable. In fact, everything gets really complicated only by the truly unpredictable force of other peoples' actions.

3. Cinema

There's a strategy of framing that you've used that radically rethinks the commercialized versions of interaction that dominate the popular imagination. You're complicating the idea of what counts as interaction as something that simply carries through, and in this we see a very specific critique of the rectangular screen space that normally dominates not only cinematic space but also computer games. How would you explain the commitment that interactive media seem to have to the cinematic screen?

Certainly there's a formalist idea that we've progressed from painting to photography to cinema to interactive cinema, that it's all a cumulative process. First, there's the direct recording of light, then motion, then sound, then color. In this story, everything just gets better and better until you finally arrive at a point where you can enter the movie and tell it what to do; it all leads to interactive narrative.

But there's also a singularity in how the audience is scripted into a rectangular space, how they all are oriented in the same direction; a disciplining. The locus is in this singular mass that's all facing the same way, all doing the same thing, all in darkened space; all reduced in some way.

Since a lot of people are looking for that experience of interactive cinema, the fastest way there is to just imitate cinema. This is what I think a lot of video games do, and now, repaying the compliment, cinema imitates video games imitating cinema. Certain elements are never questioned, never up for grabs, because if they were, you wouldn't have that sort of familiarity with it, you wouldn't be so sure about what you're supposed to do. This is at least part of the reason for the success of video games.

4. Team Effort

We can define your genre as something like: projection over which you can act and into which you can interact and interfere. All of this emphasizes the realtimeness of the experience. Contrast this with the cinematic space where you write the review afterwards. When you're immersed in a space, the sensemaking is different from the experience, because the genre is invisible to us. It seems to me that the interactive arts are all about working out the interactions. You're privileging a kind of realtime sensemaking. So let's talk about time in Timetable, because it's a big philosophical issue that you've taken up very confidently but very lightly.

When I did the research for this piece, I read lots of pop science books, first on relativity, then quantum physics, and I was drawn especially to the idea, originally proposed by Hugh Everett and then popularized by David Deutsch, that multiple universes are branching off constantly all the time. Some physicists take this idea perfectly seriously, and it seems like science fiction to the rest of us. It's a nice metaphor for the kinds of interaction that I'm interested in, where your experience is, on the one hand, continually in the same space as everybody else, but with each person bringing their own forces to bear so that everyone is always in a process of splitting off.

So let's look at this as an image of a collaborative mass working together. There's a very impoverished representation of how people do work together, all these sorts of corporate ideas like team playing or individual heroic representations. And you're making images of complex and various interactions and collaborations.

With a team effort there's an assumption that you all have the same goal, which in the case of a corporation is profit. In the case of an individual effort, it's you against the world. But here you have something where everybody's working out their goals as they go along. No one individual is determining what's happening, even though everyone might be trying to cooperate. This process is explicit in *Workaholic* because there everyone affects a single object, the swinging bar-code pendulum. So you have to cooperate at the outset to get the pendulum moving, and once you've done that you need to pay attention to what other people are doing or you can't do much of anything.

The words 'collaboration' and 'cooperation' are both kind of icky in some way because they both imply this perfect relationship where you always agree on everything. Both words seem pale, flaccid, like a lesson on Sesame Street. Everybody's groupsy-woopsy, let's all work together.

I've used both words in describing how people operate in these pieces, but I think there's a lot of conflict as well. I like it when people work together in the pieces, but I certainly don't build in things that make it too easy to cooperate.

In images of work that are delivered to us via information technologies, there is little representation of how work actually gets done together. It's an impoverished representation of how we work in groups.

Contrast that with watching little kids play together. They don't necessarily play *together*; often playing together means they'll just go off into their own corners and work out something by themselves. Then, for no discernible reason, there's a huge conflict about who can do what and whether someone can use some toy, and then all of a sudden everything is all sunshine again. It's a process that we adults don't quite understand, but it clearly has its own logic.

What separates it from the representation of work that you're describing is not only that there's conflict, but that there's not even any agreement about what the goals are, or if there even is a goal. Even the terms of what would constitute a goal are up for grabs. And in the world of smiling corporate ideology, you can't have these kinds of conflicts. You have to agree on at least your ultimate goals. Of course the way that you get there might

involve conflict, in fact that's what leads to one genre of corporate narrative, where, for instance, the heroic project team is stymied by the tradition-bound executives in their fight to bring the next great product to market. But even there the true goal is known to all. Hopefully that's not the case here.

How do you retrieve this diverse activity that is work, that is interpretation, that is making sense of the world and deciding what to do, and doing all this always and already with other people, in relation to other people … how do you retrieve this from these corporate information technologized reductions of what counts as interaction, what counts as work, what counts as a goal?

There has to be some space for really contentious kinds of relationships between people that can't be summed up as moving forward toward some goal. *Workaholic* is again probably the most explicit about this question. Even the title is about the compulsion to do work for its own sake, to overwork. We think of work as something unpleasant, but the workaholic never wants to stop working. And in that sense the piece itself is the workaholic. The bar-code scanner is continually doing work that it just can't stop, because it's a pendulum, and because work has a scientific meaning as well: force times displacement. The literalization of work.

5. Lurkers

I've been watching lots of corporate videos, corporate visions of the future that envision how people work with information technologies, technologies that are supposed to deliver the future. This material represents the ways that information technology companies are imagining the material culture they're supplying for us. What's interesting is that no one's ever learning, ever looking at how other people do something, ever actually having any difficulty with anything. This is completely counter to real experiences with information technologies.

Then I read a statistic about listservs and chat rooms: 37 percent of questions go unanswered, and of those that are answered, 37 percent of the answers are off topic. We're all lurkers. Everyone's a lurker before they become a performer. There's a mode of scripting or enlisting or enabling people that goes through a process where we just observe for a while, get to understand the context of what can be done, the vocabulary that can be used.

In a lot of screen-based media, you're left to your own resources to figure out what to do, because everything is addressed to you as a singular person. I'd rather have an informal space where there's no beginning, no end, no point where you're completely in or completely out, a gradual, nuanced space where anyone can be present whether they're interacting or not. I want to make pieces that invite people to lurk. Lurking carries a pejorative meaning, but in fact it's a large part of experience. We don't go out there and instantly respond, often all we want to do is watch and see what we can find out. Probably one of the reasons that lists and chats are popular is the opportunity they provide to be someplace without necessarily having to take a position or having to be active.

Clearly it's a crucial position that's not at all scripted into what you have called the 'monogamous relationship' between a screen and a person. The user is either a novice or an expert and nothing in between, and this doesn't account for the every-six-months software upgrade, or for the fact that participating in an information age involves an ongoing process of always learning, always interpreting, always interacting and trying new things, and never being a novice, never being an expert. And that's something that you've scripted into your information technologies, your information experience. I'm contrasting it with the corporate delivery of information culture not only because that's what dominates the popular imagination, but because I think it dominates the interactive art world as well.

The very concept of interactivity is problematic and should be made problematic. There's no absolute line between interaction and non-interaction, and so much of interaction is about a negotiation between expertise and total frustration. It's not always pleasurable and it's not always transparent. Unless our ideas about interactivity are kept open we're not going to find out much about it. There are many different modes of interacting, but most of what I see being done tends to fall back on a few formal models.

Usually it's a sort of flowchart of instructions. There was a sociologist who said that you could replace the word 'interaction' with 'social' because interaction is such a rich and diverse area.

The human–computer interface is already social in the sense that there's a deferred interaction between you and the people who made the hardware, the software, the applications. But I find it more interesting to work with groups: groups of machines, groups of people; putting them all together at once so that you're not just stuck with an information system interfaced to a biological entity. I want situations where there are all kinds of possible interactive threads between many diverse elements: people, machines, components of machines, software, hardware, avatars, alliances, memories, conflicts.

The challenge that your work offers to formal models of interaction – those goal-directed plans of how people think, proceed, make sense of things, how they can therefore can be pre-empted by pull-down menus and scripts that have finite sets of choices – the challenge that you issue is really to this formal model of what it is to interact, by presenting this informal capacity for diverse interactions, most of which haven't been prefigured or a priori scripted. It's a challenge to artificial intelligence and its popularization, which we see in human-computer interaction models that produce the information technologies that you're working with. Instead we have interaction in another sense: here is a world, I'm going to test it, see what kind of feedback I get. All of these pieces are tremendously open-ended.

Once you open them to the public and have a stream of people coming and going, the situation itself becomes open-ended. It's interesting how you can have an essentially limited apparatus made up of hardware and software that can lead to something wide open. After all, there aren't many things a dial can do, or a blast of air, and I have limitations in making these things since I'm not a big corporation and don't have unlimited funds. So it's amazing how many diverse scenarios you can get out of this stuff just by adding a group of people.

6. Materials

The tools that I'm using are all the same tools that are used for all kinds of other, often more commercial, enterprises. You start with an operating system, and then figure out how to interface different kinds of devices, using commercial software, writing software using tools that build on other tools. All of these pieces are cobbled together from different elements that either open up or close down possibilities for developing them up to and past a certain point.

There's a kind of rhetoric that the applications program is the real creative force. I'm not saying the people who write the programs aren't creative, but I find the idea that creativity has become something you can buy in a box deeply offensive. On the other hand, the possibilities for different kinds of production are clearly opened up by different kinds of software, by work that other people have done often for strictly commercial reasons, and sometimes for their own projects.

I think it's an important point then about the heterogeneous tools that you've used. Even though these are often reductive; for instance, the absurd control that you give people in Workaholic …

It's very indirect …

… but not actually that different from a mouse.

A really clumsy mouse!

So in terms of technological determinism – where many people look for the politics in the code, asking is this software enabling or restricting what we can do – you've detonated that by taking away that power that the technology itself can be determining, that the software can be restrictive.

Software packages are almost like found objects in the Duchampian sense. They do some things, and they can't do other things. The software companies are always saying: our software allows you to do anything, it gives you the ultimate creative freedom! Of course, there are always tasks that are completely outside their realm. If software comes along that lets me do something that I couldn't do before, I might use it. But that doesn't mean that my work has therefore become nothing but a result of that software. It's just a found object that I'm using for my own purposes.

Of course there are agendas embodied in software, histories and origins in the military, surveillance technologies, commercial entertainment. But that's not determining. It's obvious with something like bar code; everybody knows where it comes from and what it does. That simply gives you a point of entry, a bit of resonance. These are meanings that come along with it as a found object. I think it's the same with, for instance, sophisticated 3D graphics or even crummy 2D Pac-Man graphics. They're all elements that can be used to your advantage, either

in a critical way or by using them to explode themselves, completely contradicting their original purpose.

7. Systems

The fear of bar codes is that they reduce everything to a number, that everything becomes contained by a bar-code description, a comprehensive, complete categorization system. What you do with bar code takes away its determining power, the idea that it can and is and will be this perfect technology. You demonstrate that in fact it doesn't have any determining power, that it can be and will be used in diverse ways.

I hope so, but it's difficult for me to always be sure exactly what I'm doing. Look at the surveillance and tracking that are routinely done online and in the commercial sphere, where you're shopping and being watched by video or by cookies, devices that locate and categorize people and their actions. In some ways these are the same technologies that are used in interactive artworks. You're often trying to track somebody and figure out what they're doing. Certainly in some works that are supposed to be purely aesthetic, or optimistic, or neutral, there's nevertheless something ominous about the way the system tracks you.

So when you use these technologies, you want to make sure that in any transaction you're giving more back to people than you're taking away from them by reducing them to a position in space. While technologies aren't necessarily deterministic, you can't get away from the uses that certain ones are usually put to.

When I met them recently, the Vasulkas said that they stopped making electronic art because they didn't want to deal with the whole corporate domination of equipment.

As long as you make things, you're interfacing with the culture at large, including corporate culture. There's a natural tendency to think: 'whatever was already there before I came into the world is good, and whatever came afterwards is bad'. We see the world as it was when we entered it as natural and neutral, with later developments seen as man-made aberrations. I'm completely sympathetic to this irrational mode of thought. I love the idea of cobbling things together out of so-called low-tech

elements. I find old technologies incredibly evocative and seductive, but where you draw a line is, in a larger sense, completely arbitrary. Certainly there are good reasons to salvage old Commodore 64s to make artworks, but obviously there's nothing less corporate about a Commodore 64 than a Pentium 4.

8. Rhetoric

You're taking on what the corporate information technologies have defined as interaction, what they've defined as the interface to the machine, what they've defined as who gets to interact and what gets to be considered interaction. So in that sense, this is a highly politicized exhibition even though there's nothing overtly political about it. What's at stake here is who and how we get to interact with our material culture.

My relationship to all this stuff is, on some level, very personal. I don't tend to think of making very didactic points through the work, but a lot of it does end up being about my specific relationship to the technologies, the entities that create the technologies, what I can do with these technologies, how I feel about them. I'm trying to figure out my relationship to all of it.

Finally, and this is an interesting inversion of what we were saying at the beginning, you're demonstrating and framing what you as the information technology artist can do, using yourself as the proxy for an individual, and therefore showing what an individual can do in a world that's created by corporate technologies.

There's been a lot of rhetoric over the years about ending distinctions between artists and designers, artists and researchers, rhetoric that insists on an equivalence between all kinds of creative work. I think it's important to be able to ask not just whether something is well-designed, but to talk about what its ultimate purpose is, and to be able to understand it in those terms. In that light, it makes a difference whether someone is working in a corporate context, doing something practical or commercial, or if that person is free to define their own goals.

Historically, we can make a comparison between the concerns of the electronic arts of the seventies, for instance, the work of Nam June Paik or Bill Viola, whose work was concerned with the poetics of individual experience. Current work, including yours, seems instead to be concerned more with the politics of individual experience.

Individual experience has become a contentious arena, as market forces take over more and more of our lives, and are understood to be the only things that matter. The politics of how individuals experience the world is almost in danger of extinction. It isn't that people don't have individual experiences, but they're just not taken as meaning that much any more. We're all becoming part of one big mass.

Brooklyn, New York
July 23, 2001

An illustrated text in the fashion of a Family Album for Perry's exhibition at the National Museum of Photography, Film and Television, Bradford

Music is playing in the darkness
And a lantern goes swinging by
Shadows flickering my heart's jittering
Just you and I
Words and music by John Deacon

Jo vinc d'un silenci
que no és resignat,
d'on comença l'horta
i acaba el secà,
d'esforç i blasfèmia
perquè tot va mal:
qui perd els orígens
perd identitat.
Words and music by Raimon

Noche tibia y callada de Veracruz,
cuento de pescadores que arrulla el mar,
vibración de cocuyos que con su luz
bordan de lentejuelas la oscuridad.
Bordan de lentejuelas la oscuridad.
Words and music by Agustín Lara

When my brother Narcís and I were barely teenagers [Mexico DF, c. 1980], we believed we had very few things in common. While Narcís spent most of his free time in his room methodically designing impossible roller coaster rides, which he exotically named 'Typhoon' or 'Sirocco', I would lie on the living room sofa watching 'cablevision' ads or playing 'intellivision' console games, killing time until my next classmate's birthday party. While he was modeling ready-to-explode planets built in *papier maché* and stuffed with gun powder and building starships with balsa wood and aluminum foil for his super-8 sci-fi experiments, I was learning some teamwork strategies during my rock band rehearsals playing bass guitar.

Rollercoaster sketches
by Narcís Parés (age 16)
Mexico 1982

intellivision™

r-8 sci-fi experiments
arcís Parés (age 15) Mexico 1981

61

One thing we did share at that time was rock music – even though it was only him who had the patience to save enough pesos (mostly earned by washing Dad's Chevrolet Caprice) to buy the imported albums. Devotion to Queen, Yes, Pink Floyd and David Bowie was inculcated into both of us by our cousins Marc and Enric – ten years older than us – who heroically pioneered the rock revolution in the incipient Mexican underground arena of that time, together with their bands.

I'll never forget those records played endlessly and loudly across the corridor ... smoothly spinning on the Technics turntable our parents bought during one of those family trips to the States, visiting theme parks, art museums, and shopping malls full of products (mostly unavailable in Mexico) the prices of which we learned on *The Price is Right*.

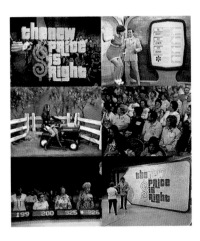

The Price is Right™

Our teenage pop culture – as it appears in the lines above – had nothing to do with the popular culture of our family's original country: Catalonia, the land which our defeated and impoverished grandparents left, heading for Mexico, after the Spanish Civil War was won by the fascist regime of General Franco in the year of 39 ... a different year of 39 from the one Brian May wrote about. Our teenage pop culture, strangely alternative to my Mexican classmates' top ten chart disco parties ... Our teenage pop culture: sometimes too loud for a busy factory owner like Dad, who often came home late from work to relax over some classic jazz standards, practicing with the putter on the living room carpet, wishing he had more time to go and play at the club ... way too dark for Mom, who now and then managed to find some rare Raimon or Lluis Llac records; new Catalan music clandestinely recorded and politically involved, ever fighting against the censor-

ship and silence of the last but no less dramatic ten years of dictatorship in the distant and ever longed-for Catalonia.

Ten years later (Barcelona, circa 1990) my brother Narcís and I were savoring the last sips of our teens having survived the experience of saying goodbye to Mexico. In '83 our parents decided to bring their inherited exile to an end. Brother, Mom, Dad, and myself struggled to redo our lives in a new environment, so different from the country my grandparents left fifty years ago. Narcís was finishing his degree in Computer Science while I wished I were quitting my Fine Arts studies. I was in love with Blanca, who claims she fell in love with me because of my long hair and my rock band, in '87 or so.

In Barcelona we get the chance to see our teenage idols perform live; the concert tickets become my only collection. Queen, Pink Floyd, Yes, David Bowie – like the rest of the thirty-six rock stars that I get to see and hear live – are probably not in best shape but they sure bring back precious memories of their records. Mom and Dad work very hard in order to overcome the distant decline of the factory in Mexico, but finally manage to attend Raimon and Lluis Llac concerts (who are probably not in best shape either) without crying. Tacos and quesadillas stuffed with Mediterranean meats and vegetables become a classic in our Sunday family gatherings at my parents' house, to the amusement of our new Catalan friends who join us and patiently listen to Agustín Lara, Los Panchos or Jorge Negrete while they wipe away the tears produced by imported hot canned *chile*.

Tickets of rock concerts
which took place in Barcelona

I'll never forget those records played endlessly and loudly across the corridor ... randomly spinning on the Aiwa turntable our parents bought during one of those weekend incursions we made together to department stores during sales season: visiting housewear, clothing, groceries and other sections, looking for all those products

announced in between the programs we watch on TV3 and Canal33, the two channels of the young Television of Catalonia.

Meanwhile, to the surprise of our parents and friends, Narcís and I start working together as an independent team called Galeria Virtual. We decide to experiment with virtual reality as an art medium. No one else does that in post-Olympic Barcelona, '93. We have both graduated, he's just about to finish a Masters program in Computer Graphics and Artificial Intelligence and marries Isabel, who is a computer scientist as well.

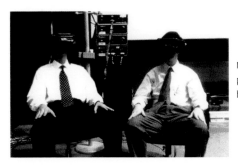

Narcís and Roc photographed by Txell, 1993

Our teenage pop culture, now remixed with Mexican popular culture – as it appears in the lines above – clearly had nothing to do with the culture of our family's original country: Catalonia, the land to which our parents have taken us from Mexico, just before Narcís and I could say 'No thanks, we're staying.' Our recovered Mexican popular culture, now merged with our teenage pop culture: strangely alternative to the top ten charts of the disco parties that my classmates in Barcelona revive ... sometimes still too loud for a self-remade-man like Dad, who often came home late after work, and relaxed over a Barcelona football match on TV ... way closer to Mom, who now and then watched on TV her favorite Mexican or Hollywood films dubbed into Catalan in these first ten years of democracy and the recovery of the institutions of Catalonia.

Ten years later (Barcelona, circa 2000). Narcís and Isabel have two kids, Julia and Marc, ages four and two. Blanca and I have a sixteen-month-old son called Rem. Narcís and I have recently become doctors after finishing our PhDs in Audiovisual Communication.

Our thesis dissertations about VR, art and communication are both written in Catalan, as are many others in this country where language is no longer the main cultural problem. Mom has retired to become a super-granny who often listens to the complete collection of Raimon's music on CD. Dad has become a senior amateur golf player, handicap 28.4, at his local public course. He doesn't need to go to the office daily since he understands computers and the Internet admirably, especially in comparison to many of our senior colleagues at the Audiovisual Department of the university, who still think that the real audiovisual communication is cinema and TV.

Moving into our mid-thirties, Narcís and I have changed our minds and agree that we have many things in common. The most human and personal aspects of the imagineer and the rock star we always dreamt of becoming have been fulfilled through the five non-commercial virtual reality experiences that we have created together with different artists, writers and composers.

The fourth one is called El Ball del Fanalet or Lightpools. This installation was developed by first establishing what sort of interpersonal communication we wanted to propose for the audience, then which hardware, software and space requirements were needed, and finally the look and feel of every element. Once this process of interaction design had been completed (from the bottom up), the flavor of a popular Catalan dance (El Ball del Fanalet) seemed to be an appropriate and inspiring referential framework for the casual interaction we were looking for.

Today it is our privilege to present Lightpools as part of Perry's show at the National Museum of Photography, Film and Television, in Bradford. In fact, it was a privilege for us to get to know Perry and his work back in 1993, in the Rocky Mountains. Working with him we have proved to ourselves that the digital technologies of our globalized world in the twenty-first century don't necessarily bring us to a more homogenized version of the société du spectacle. And at the end, we have been able to convince most of our colleagues at university that virtual reality can also be an audiovisual interactive medium that offers extraordinary aesthetic and social participation possibilities.

Perry Hoberman

Perry Hoberman is an artist who works with a wide variety of media and materials, ranging from the utterly obsolete to the state of the art, from low- to high-tech and everything in between. His work has variously taken the form of installations, sculptures, multimedia, performances, concerts, plays and uncategorizable spectacles. Over the years, Hoberman has been called such things as: 'a master of mechanized trickery,' 'a visuals wizard,' 'an archaeologist of consumerism,' 'the world's foremost appliance artist,' 'one of the prime movers in the field,' and 'no stranger to the attractions of technology.'

After completing his studies at (BA Painting/Music 1977), Hoberman moved to New York, where he initially worked as a commercial animator while attending the Whitney Independent Study Program in 1978. He began a long association with the performance artist Laurie Anderson in 1979, working as a projectionist, musician, visual director and producer. In 1980, he moved to Williamsburg, Brooklyn, which has been his home base ever since. He began investigating the medium of stereoscopic slide projection in 1982, eventually producing a series of acclaimed installations and performances that were widely exhibited in the US and Europe throughout the 1980s. His work was included in the 1985 Whitney Biennial, and his one-person exhibition that year at Postmasters Gallery was the first of seven to date. Also in 1985, Hoberman began incorporating digital techniques and technologies into his work.

Hoberman was a visiting faculty member at the San Francisco Art Institute in 1991 (where he and his students were pioneers in the nascent field of Radical Neo-Art Karaoke), and he has continued teaching since then in New York at the Cooper Union and the School of Visual Arts. In 1992 he was invited to produce a virtual reality project at the Banff Centre for the Arts, where he completed the installation *Bar Code Hotel* in 1994, which received the Grand Prize at the 1995 Interactive Media Festival. Between 1993 and 1996 Hoberman was the Art Director at Telepresence Research, a Silicon Valley company specializing in virtual reality. A retrospective of Hoberman's work, 'Unexpected Obstacles,' premiered at the Otso Gallery in Finland in 1997, and traveled next to the Zentrum für Kunst und Medientechnologie in Karlsruhe, Germany, in 1998. In 1999, two newly commissioned works were awarded prizes: *Systems Maintenance* received an Interactive Art Prize at the Prix Ars Electronica, and *Timetable* won the Grand Prize at the ICC Biennale.

http://www.perryhoberman.com

Selected Bibliography

Laura Steward Heon, *Game Show: An Exhibition Spring 2001-Spring 2002 Mass MOCA*; paperback, 135 pages; July 2001; Te Neues Publishing Company, New York; ISBN: 09-7007-382-8

Joke Brouwer and V2_Organisation, editors, *Machine Times*; paperback 192 pages, November 2000; NAI Publishers and V2_Organisation, Rotterdam, ISBN: 90-5662-189-0

Peter Lunenfeld, *Snap to Grid: A User's Guide to Digital Arts, Media, and Cultures*; hardcover, 240 pages; April 2000; MIT Press, Cambridge, MA; ISBN: 02-6212-226-X

Christian Viveros-Fauné, 'Computer World', review, *The New York Press*; Feb 2-8, 2000

Caroline A. Jones and Peter Galison, editors, *Picturing Science, Producing Art*; paperback, 518 pages; 1998; Routledge; ISBN 0-415-91912-6

Erkki Huhtamo, 'Beams of Light in a Virtual Void', article, *Artbyte*; Vol. 1 No. 1, April–May 1998, New York

Paivi Talasmaa, editor, *Unexpected Obstacles: The Work of Perry Hoberman 1982–1997*; Galleria OTSO, Espoo, Finland, 1997

Artintact 3, CD-ROM Magazine, 1996, Zentrum für Kunst und Medientechnologie Karlsruhe, Cantz-Verlag, ISBN: 38-9322-861-6

Margot Lovejoy, *Postmodern Currents: Art and Artists in the Age of Electronic Media*; paperback, 319 pages; November 1996; Prentice Hall; ISBN: 01-3158-759-5

Jon Dovey, editor, *Fractal Dreams : New Media in Social Context*; paperback, April 1996; Lawrence & Wishart, London; ISBN: 08-5315-800-2

Mary Anne Moser and Douglas MacLeod, editors, *Immersed in Technology: Art and Virtual Environments*; hardcover, 368 pages; January 1996; MIT Press, Cambridge, MA; ISBN: 02-6213-314-8

Perry Hoberman, 'Beyond Hope and Beyond Dreams: The Neo-Karaoke Story', *Publicsfear No. 3*, New York, 1993

Roberta Smith, 'Perry Hoberman', review, *The New York Times*, May 18, 1990

John Rockwell, 'Marclay, Hoberman, Sound and Fury', review, *The New York Times*, October 22, 1989

Timothy Druckrey

Timothy Druckrey is a curator, writer, and editor living in New York City. He lectures internationally about the social impact of electronic media, the transformation of representation, and communication in interactive and networked environments. He co-organized the international symposium *Ideologies of Technology* at the Dia Center of the Arts and co-edited *Culture on the Brink: Ideologies of Technology* (Bay Press). He also co-curated *Iterations: The New Image* at the International Center of Photography and edited the book by the same name published by MIT Press. He recently edited *Electronic Culture: Technology and Visual Representation* and is series editor for *Electronic Culture: History, Theory, Practice* published by MIT Press. The first volume Ars *Electronica: Facing the Future* was published in Fall 1999, the second, *net_condition: art and global media,* in Fall 2000.

Juha Huuskonen

(Code and interface design assistance, *Timetable*)

Juha Huuskonen graduated from the Computer Science Department of Helsinki University of Technology (major subject Interactive Digital Media) and did his minor subject studies at the Media Lab of the University of Art and Design, Helsinki. He is currently working as a media artist, teacher and technology consultant.

Juha has long working experience in designing and implementing software for various platforms, focusing on user interfaces and advanced real-time graphics. His previous employers include Mindworks Oy, MTV Networks Europe (London) and CERN (European Nuclear Physics Research Center, Geneva). He has also worked on exhibition multimedia projects for the Finnish National Museum, Alvar Aalto Museum and Heureka Science Centre.

Juha is the chairman and one of the founders of media art collective katastro.fi. He is also one of the initiators and organizers of the first Avanto – Helsinki Media Art Festival (November 2000). Juha's own artistic work deals mainly with real-time visualization of sound and movement. It has been shown at Artgenda'00 Biennale in Helsinki, Realm of Senses exhibition in Turku and on the F2F exhibition tour of the United States and Canada.

http://katastro.fi/~juhuu

Natalie Jeremijenko

Natalie Jeremijenko, design engineer and technoartist, was recently named one of the top one hundred young innovators by the MIT Technology Review. Her work includes digital, electromechanical, and interactive systems in addition to biotechnological work. Her work was recently featured in *Cream 2*, a Tate gallery publication surveying contemporary art. It has also been presented in the Rotterdam Film Festival (2000), the Guggenheim Museum, New York (1999), the Museum Moderne Kunst, Frankfurt, the LUX Gallery, London (1999), the Whitney Biennial 1997, Documenta 1997, Prix Ars Electronica 1996, the Museum of Modern Art, New York and the Media Lab of the Massachusetts Institute of Technology. A large project was commissioned for the opening of the new museum MASSMoCA (www.massmoca.org) and she was a Rockefeller Fellow in 1999.

Natalie studied graduate engineering at Stanford University as part of her PhD in design engineering. She has recently joined the faculty of mechanical engineering at Yale University and will direct the Engineering Product Design Studio, developing and implementing new courses in technological innovation. She is affiliated as a research scientist at the Media Research Lab/Center for Advanced Technology in the Computer Science Dept, NYU. Other research positions include the Advanced Computer Graphics Lab, RMIT and several years at Xerox PARC in the computer science lab. She has also been on faculty in digital media and computer art at the School Of Visual Art, New York and the San Francisco Art Institute, and is rumored to work for the Bureau of Inverse Technology.

http://www.cat.nyu.edu/natalie

Narcís & Roc Parés

(Co-authors, *Lightpools*)

Galeria Virtual is a research and experimental production team, working on interdisciplinary projects which integrate contemporary art and digital audiovisual technologies, paying special attention to Virtual Reality (VR). Since February 1993, Galeria Virtual has worked on different proposals in collaboration with artists and intellectuals (J. Fontcuberta, P. Hoberman, M. Serra, A. Lewin-Richter), published specialised articles (British Computer Society, Academic Press, Presence, etc.) and participated in international exhibitions and conferences (Centre d'Art Santa Mònica, Art Gallery Ontario, MNCARS, Tate Gallery, among others). This work has received a good deal of media attention (City TV, Canal+, Cape X, World Art, ICCNews, etc.), the interest of curators and critics (D. De Kerckhove, J. L. Brea, J. Lebrero, J. Grieve, R. Ascott, etc.), and grants and funds from private and public institutions (Museu de la Ciència, KRTU, Fundacio Joan Miro, etc.). Since 1994 Galeria Virtual has developed its work at the Audiovisual Institute, Universitat Pompeu Fabra, Barcelona.

Dr Narcís Parés, Technical Director (npares@iua.upf.es); Doctor in Audiovisual Communication speciality Virtual Reality, UPF; Computer Science Engineer, UPC.

Dr Roc Parés, Artistic Director (rpares@ iua.upf.es); Artist; Interactive Communication Professor, UPF.

http://www.iua.upf.es/~gvirtual

Elliott Sharp

(Composer, *Timetable*)

Composer/multi-instrumentalist/producer Elliott Sharp leads the groups Orchestra Carbon, Tectonics, and Terraplane. His compositions have been performed by the Symphony of the Hessische Rundfunk, the Ensemble Modern, Continuum, the Orchestra of the SEM Ensemble, Kronos Quartet, Zeitkratzer, the Soldier String Quartet, Meridian String Quartet, and the Quintet of the Americas. His collaborators have included qawaali singer Nusrat Fateh Ali Khan, cello innovator Frances-Marie Uitti, sci-fi writers Jack Womack and Lucius Shepard; blues legend Hubert Sumlin; turntablists DJ Soulslinger and Christian Marclay; and Bachir Attar, leader of the Master Musicians of Jahjouka.

He formed zOaR Records in 1978 to release his own and other extreme musics and produced the critically acclaimed compilations *State of the Union* and *Peripheral Vision*.

Sharp's latest CD releases include SyndaKit with Orchestra Carbon on zOaR; Terraplane: *Blues* for Next; and Tectonics: *Errata*, as well as the latest *State of the Union 2.001* on the Electronic Music Foundation label.

His interactive string/computer installation *Chromatine* recently premiered at the gallery of the School of the Boston Museum of Fine Arts.

www.algonet.se/~repple/esharp/es.html

Christian Viveros-Fauné

Christian Viveros-Fauné is the art columnist for The New York Press. He has written extensively for various national and international publications, among them *The New Yorker*, *Art in America*, *artnet*, *ArtNews*; *Art Nexus* (Colombia); *El Mercurio* and *La Tercera* (Chile); *Frieze* (UK); *Lapiz* (Spain);and *Tema Celeste* (Italy). He has also lectured widely both in American universities and abroad and has written catalog essays for museum exhibitions in the US, Latin America and Europe, most recently for *Authentic/Excentrican* exhibition of contemporary African art at the 2001 Venice Biennale. Viveros-Fauné is also co-director of Roebling Hall, an art gallery located in Williamsburg, Brooklyn. He is presently at work on *You Looking at Me?*, an exhibition of contemporary art from Brooklyn scheduled to open at Barcelona's Palacio de la Virreina in 2002.

Siegfried Zielinski

Siegfried Zielinski studied philosophy, theatre, German philology, media, political science and linguistics in Marburg and Berlin. He was a lecturer in media studies at the Technical University of Berlin (1980 –89), professor of audiovisual studies at the University of Salzburg (1990–93), and founding director of the Academy of Media Arts, Cologne (1994–2000); he is currently chair of communications and media studies at the Academy of Media Arts, Cologne (1993–). He researches and publishes with an emphasis on the integrated history, theory and practice of audiovision/ archaeology of the media. His last book published in English was *Audiovisions – Cinema and Television as Entr'actes in History*, Amsterdam University Press, 1999. He is a member of the European Film Academy; the Academy of Arts, Berlin; and the Magic Lantern Society of Great Britain.

Workaholic (2000)

Produced for and on behalf of the Museums of the City of Dortmund
Premiered at 'Vision Ruhr', Zeche Zollern, Dortmund

Timetable (1999)

Composer: Elliott Sharp
Code & Interface Design Assistance: Juha Huuskonen
Real-Time 3D Rendering Engine: SurRender 3D
Produced by NTT InterCommunication Center
Premiered 1999 at ICC Bienniale 99, Tokyo
Winner, Grand Prix, ICC Biennale 99

Lightpools **or** El Ball del Fanalet (1998)

by Perry Hoberman & Galeria Virtual (Narcis Parés & Roc Parés)
Programming: Narcís Parés & Xavier Artigas
Produced in collaboration with the Institut Universitari de l'Audiovisual
of Universitat Pompeu Fabra, and with the technical suport of Compaq
Computer, S.A., Wand Wave S.L. and Sense8 Inc.
Premiered at "Singular Electrics", Fundació Joan Miro, Barcelona